Beginner's Guide to Cameras

Beginner's Guides are available on the following subjects

Audio
Building Construction
Cameras
Central Heating
Colour Television
Computers
Digital Electronics
Domestic Plumbing
Electric Wiring
Electronics
Gemmology
Home Energy Saving
Integrated Circuits
Photography
Radio
Super-8 Film Making
Tape Recording
Television
Transistors
Woodworking

Beginner's Guide to
Cameras

Derek Watkins

Newnes Technical Books

Newnes Technical Books

is an imprint of the Butterworth Group
which has principal offices in
London, Sydney, Toronto, Wellington, Durban and Boston

First published 1981

© Butterworth & Co (Publishers) Ltd, 1981

British Library Cataloguing in Publication Data

Watkins, Derek
 Beginner's guide to cameras.
 1. Photography
 I. Title
 770'.28'2 TR146

 ISBN 0-408-00510-6

Photoset by Butterworths Litho Preparation Department
Printed in England by Fakenham Press Ltd, Fakenham, Norfolk

Preface

Taking technically good photographs has never been easier than it is today. Thanks to fully automatic cameras a complete beginner knowing absolutely nothing about shutter speeds, apertures and the other technicalities of photography can go out and take perfectly exposed pictures. Less than a decade ago this would have been extremely difficult if not impossible.

Yet although the technical side of photography has become far easier, because it can largely be forgotten or ignored, the choosing of a suitable camera has become, if anything, more difficult. Quite simply, there are so many cameras on the market, each offering its own combination of so-called unique features, that it is difficult for even the expert to choose with confidence.

I've lost count of the number of times someone has come up to me and said, 'I want to buy a camera. Which is the best one to get?' When asked what they want to use it for, I'm usually confronted with a blank look and the answer, 'To take photographs, of course'. But they miss my point. Different kinds of photography need different types of camera to produce the best results. What's best for shooting landscapes won't be suitable for taking action pictures at motor race meetings. What's ideal for portraits may be next to useless for shooting close-ups.

Of course, if you're interested in several different types of photography you'll have to compromise and pick a camera which does a reasonable job on all types of pictures. And

your choice will almost certainly be a 35 mm single lens reflex, currently the most versatile and popular type of camera.

In the chapters which follow we shall be looking in detail at SLRs and other types of cameras from pocket Instamatics to sheet film studio cameras. I hope the book will clear up a lot of the problems which may face you and will point you in the right direction to make the best choice for you.

<div align="right">D.W.</div>

Contents

1

Getting started

Most people don't make a conscious decision to take up photography as a hobby. Instead, they seem to drift into it as a spin-off from some other interest. It's probably true to say that a large number begin by taking photographs on holiday to record the places they've visited and the people they've met or been with. They use photography as a happy moment recording system. Others buy a camera when they have children to record their family growing up. Others may follow a sport or have an interest in, perhaps, archaeology and find that taking photographs can add to their enjoyment or to the information they gather.

Many of the people who use photography in this way never take it any further. They are quite happy with the pictures they take and don't want to become involved with more complex and expensive cameras which they would only use in basically the same way.

However, many others get bitten by the photographic bug and take up photography as a main hobby. Unfortunately, a large number become hooked on equipment and spend a great deal of money collecting cameras, lenses, exposure meters, filters and all other kinds of equipment without really knowing how to make the most of it. Equipment manufacturers and, to some extent, the photographic press, foster the idea that you need vast amounts of equipment in order to be able to take good photographs. The result is that a lot of would-be photographers clutter themselves up with a great deal of equipment which they never use.

So let's have a look at a few different types of photography and see which is the best type of camera for each. But first, just a word about negative sizes. All other things being equal, you'll always get better quality results from a large negative than you will from a small one, and by the same token, it's possible to produce results just as good on a modestly priced camera taking 6×6 cm pictures as it is on a very expensive 35 mm camera. Unfortunately, there are very few modestly priced 6×6 cm cameras available new these days, but if you check the secondhand columns in the photographic press you'll often see good secondhand folding cameras for sale at very low prices. True, they won't have all the features of a modern single lens reflex, but this isn't always such a bad thing as the basically simple controls will teach you a lot about the technicalities of photography. And anyway, we're talking about a camera costing only a third or a quarter what you'd have to pay for a reasonable 35 mm SLR, and what you lose in convenience you'll make up for in better picture quality.

Holiday pictures

Years ago, practically every family had a Kodak Box Brownie or equivalent box camera. It was the simplest form of camera you could buy and as its name implies, it consisted simply of a box with a lens at one end and a film at the other. Behind the lens was a very simple shutter mechanism and above the lens a rudimentary viewfinder. This simple type of camera was designed to take passable black and white pictures in normal daylight conditions. Most had no controls apart from the shutter release and a film winding knob. They were perfectly adequate for the job they were designed to do, but they were rather bulky to carry around and over the years the manufacturers gradually made them smaller and instead of taking pictures $2\frac{1}{4} \times 3\frac{1}{4}$ in $(6 \times 8.5$ cm) on 120 size roll film, later box cameras took pictures $1\frac{5}{8} \times 2\frac{1}{2}$ in $(4 \times 6.5$ cm) or $1\frac{1}{8} \times 1\frac{5}{8}$ in $(3 \times 4$ cm).

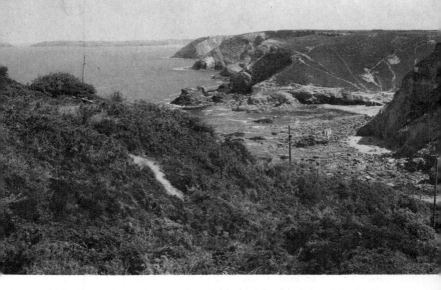

Virtually any type of camera is suitable for taking holiday pictures. By far the most popular is the Instamatic. The coast at St. Agnes, Cornwall (Derek Watkins)

However, in the early 1960s, Kodak introduced what was to be a major revolution in simple snapshot cameras – the Instamatic – and about a decade later followed with another revolution, the Pocket Instamatic. Today, these two types of camera are by far the most popular of simple cameras; they are the modern equivalent of the old-fashioned box camera. But they're rather more versatile; most will accept some form of flash unit to let you take snapshots indoors, and many are now fitted with a simple weather symbol control which enables you to take pictures outdoors in any kind of weather from dull and overcast to bright sunshine.

If all you want from photography is to be able to take good, clear snapshots in colour so that you can have extra prints made for your friends, then the Instamatic or Pocket Instamatic camera is perfectly adequate for your needs. In fact if you don't want to become involved with the technicalities of

photography a more advanced, and therefore more expensive, camera could well turn out to be more of a liability than an asset.

The big problem with Instamatic and Pocket Instamatic cameras, though, is that the quality of the lens is not very high. This means that you can't have your snapshots enlarged very much before they start to become blurred. In recent years many simple 35mm cameras have appeared on the market which are ideal for people who want a rather better result than it is possible to obtain with the Instamatic type of camera. Many of these simple 35mm cameras are very compact in construction and are often little larger than an Instamatic. And many have fully automatic exposure control.

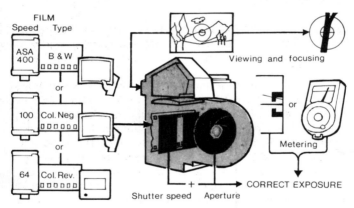

A camera provides the means to compose and focus a picture, then record it on film with just the right exposure

This means that you can use them in all kinds of conditions and still be sure that you'll get a properly exposed picture. They are, of course, very much more expensive than Instamatic cameras, but this shows up in vastly improved results.

These compact 35mm cameras, especially those with fully automatic exposure control, are ideal if you want to take colour slides rather than colour prints, because the exposure is more critical for slide films than it is for print films. Also,

35 mm SLRs are also quite good for candid pictures, but they do tend to be rather more conspicuous because of their larger size.

Landscapes and architecture

If you're interested in photographing landscapes and architecture, you have one very big advantage over those

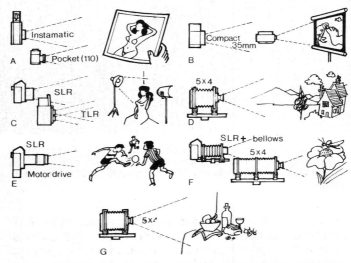

Most cameras can be used for most photography, but the best type of camera depends on the job it has to do. A. Simple cartridge-loading models are ideal for holiday or party snapshots, especially for colour prints. B. Compact 35 mm cameras offer more versatility, improved image quality, and a much wider choice of film. C. More serious work, such as portraits, benefits from screen focusing, as in a 35 mm SLR or 6 × 6 TLR. D. Landscapes or townscapes benefit from the detail available with a large format camera, and the direct screen focusing is ideal for static subjects. E. Once things get moving, an SLR, with power-wind and eye-level viewing, makes life much easier. A long focal length helps, too. F. To go really close calls for considerable lens extension, available on 35 mm SLRs with bellows, and on sheet film cameras. Screen focusing is always essential. G. In the studio again, still life work benefits from the size and versatility of a view camera

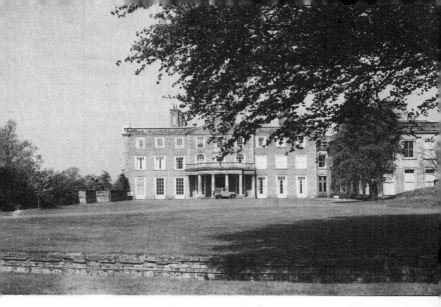

The ideal camera for architectural photography is the sheet film type, but most others will do an acceptable job. This shot of Weston Hall, Staffordshire was taken with a 35mm Olympus OM-1 (Derek Watkins)

who photograph people and wild life, for example. Your subject doesn't move. This means that you can spend a lot of time setting up your camera, choosing your viewpoint, and waiting for the lighting to become perfect before you press the shutter release. So you don't really need a fast action, highly portable camera for this type of photography. In fact, the ideal camera, in my opinion, for landscapes and architectural photography, is a 5 × 4 in (or 9 × 12 cm) sheet film camera and a heavy tripod on which to fix it.

The detail that is is possible to capture on a 5 × 4 in negative is quite incredible and even in very big enlargements the grain structure of the negative remains virtually invisible. The added advantage that a 5 × 4 in sheet film camera has is a range of movements on the lens panel and film holder. These movements enable you to control the image on the viewing screen of the camera to eliminate distortion, increase or

decrease the perspective effect, increase or decrease the amount of the subject in focus, and finely position the image exactly where you want it. This is particularly important in architectural work.

The big problem with a 5 × 4 in camera, though, is its extreme weight and bulk. While this is not too much of a problem if you can drive to your viewpoint in a car, it is not quite so convenient if you have to carry your equipment over a fairly long distance. In view of this, you may want to compromise slightly and choose a more portable camera with a somewhat smaller negative size. The large format single lens reflexes mentioned earlier are very nearly as good for landscape work as the 5 × 4 in camera, and so for that matter is the 6 × 6 cm twin lens reflex. Unfortunately, these cameras have no front and back movements like the 5 × 4 in sheet film camera has, so it is not possible to control the image in the same way. While this is not a major disadvantage in landscape photography, it can cause problems in architectural shots, although there are ways round it at the enlarging stage.

Sports and action photography

The requirements for action photography are totally different from those for landscape and architectural photography. Basically, you need a small, lightweight camera that is quick and easy to use and can, perhaps, be fitted with a motorised film advance mechanism to enable you to take several pictures in very rapid succession.

You also need to be able to use a long telephoto lens to bring the action much closer, as it were, yet still being able to focus quickly and accurately. All this virtually adds up to the specification of a 35 mm single lens reflex, and this type of camera is, without doubt, the most suitable for sports and action photography.

One of the other major requirements for action photography is a fast shutter speed, because in most cases the subject which you'll be shooting will be moving fairly quickly. A

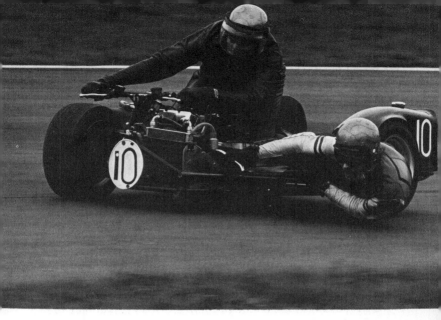

For action shots, a large clear viewfinder is essential. With the wide choice of lenses a 35 mm SLR is particularly suitable, offering the necessary range of shutter speeds and apertures (Brian Gibbs)

shutter speed of 1/1000 second is probably the best to look for, or failing that, 1/500 second.

The only really viable alternative to a 35 mm SLR for this type of photography is the 35 mm rangefinder camera. While this is suitable in most respects, it is more difficult to use in others. For example, it is not always possible to couple very long focal length telephoto lenses to the camera's rangefinding and viewfinding system, which means that you have to use separate accessory viewfinders. This is obviously not very convenient.

Larger format SLRs are also quite suitable for sports and action photography but the cost of the very long focal length lenses that you need for this branch of photography are so high for large format SLRs as to be all but prohibitive. These lenses are also extremely heavy and bulky into the bargain.

Close-up photography

This is another branch of photography which virtually specifies the single lens reflex as the ideal camera for the job. Accurate focus is one of the most important aspects of this kind of photography and the SLR is by far the easiest type of camera to ensure this when working at very close distances. In addition, most single lens reflexes have, as part of their overall system, different types of close-up attachments such as extension tubes, close-up bellows and supplementary lenses, all of which can be used very simply with this type of camera.

The sheet film 5×4in camera is also very suitable for close-up work and has the advantage that its range of front and back movements can be used to position the image accurately on the viewing screen and ensure sharp focus over the whole of the subject. Another advantage with some 5×4in cameras is that the bellows can be extended almost indefinitely to enable you to get really close to your subject and produce an enlarged image on the film. When the negative itself is subsequently enlarged, the resulting print can then show an image many times larger than the actual size of the object. The sheet film camera, though, falls down badly when it comes to photographing insects etc. in close-up. Because the image on the viewing screen disappears as soon as you insert the sheet film holder, stop the lens down and close the shutter ready for the exposure; you are, in fact, shooting blind, so any object which moves can well put itself out of focus or indeed move entirely out of the picture area before you press the shutter release to take your picture. This problem doesn't arise with the single lens reflex.

Both 35mm and larger format SLRs are ideal for close-up work and your choice is governed largely by the size of your budget.

Close-up attachments enable you to get closer to your subject than the minimum distance on your camera's focusing scale. Olympus OM-1 with 50mm lens and +2 close-up lens (Derek Watkins)

Still life photography

This is one field of photography where the large format studio camera really scores. If you look through women's magazines and high quality cookery books, the superb pictures of jewellery, perfumes, food and cooked dishes are almost certain to have been taken with a sheet film studio camera on 5×4 in or even 10×8 in colour transparency film. Obviously, this type of camera is really for the still life specialist and the professional studio man. But you can do a lot of good work with a large format SLR or a 6×6 cm twin lens reflex. However, if you intend to specialise in still life photography, possibly to the exclusion of other types,you'd do well to consult the secondhand equipment columns in the professional photographic journals.

Making your choice

As you can see, if you want to specialise in one particular branch of photography, your choice of camera is pretty well clear cut. But if you want to become involved in several different types of photography you'll have to arrive at some sort of compromise.

Probably the best compromise of all is the 35mm single lens reflex. While it is not ideal for every photographic task, it is highly suitable for most of them. It is extremely versatile and can be quickly adapted to suit a whole range of specialist applications. Viewfinding and focusing are extremely simple and you know that whatever you see in the viewfinder will appear on your picture.

But one word of warning. Don't be too easily wooed by the manufacturers' enthusiastic advertising. It is all too easy to decide, after reading a few advertisements, that the camera you need must have at least four different exposure control systems, motorised film advance, interchangeable viewfinding systems and a range of fifteen lenses to go with it. Stop and think. How often will you use anything but one of the exposure control systems? Do you really need a motor drive for the kind of pictures you want to take? When will you need a viewfinding system other than the standard? And how often will you use any more than three different lenses at the most?

It is very easy to become so attracted to the hardware involved in photography that you forget that it is only a means to an end. The important thing at the end of the day is the photograph. If you need a particular lens or other piece of equipment in order to produce the results you want, then fine, go out and buy it. But if you don't need it you're wasting your money, and that money could go towards buying a better camera or some accessory that will be useful.

Try before you buy

The ideal way to find out if a particular type of camera is suitable for you is to actually borrow one and use it. This may be rather difficult because, understandably, most camera shops are not keen to lend their equipment out. However, one or two dealers run equipment hire departments and it is possible to hire certain ranges of equipment for anything from one day upwards. It will not cost a great deal to hire a camera and a couple of lenses for a day or two and it may well save you a lot of money in the long run, because if you buy the camera that you think you need and then find out that it doesn't measure up to your requirements, you'll lose a lot of money when you trade it in for the camera that really does suit your needs.

Camera test reports in the photographic magazines are a fairly reliable way to find out if the camera of your choice is a good one, as long as you realise that the test reports are, to a large extent, an expression of the reviewer's personal opinions. What one reviewer may praise on a particular camera, another reviewer may condemn. But if there's a major problem with the camera you'll find that all the reviewers tend to pick it up.

Once you've decided which type of camera you want to buy, you must, of course, decide how much you want to spend on it. Shop around different dealers for the camera of your choice to find the best price and don't discount the possibility of a secondhand camera. But do be careful where you buy a secondhand camera. Choose a reputable dealer who is prepared to offer you a guarantee.

2

The camera and how it works

If you look up the word 'camera' in the dictionary, you'll find that it comes from a Latin word meaning 'chamber' or 'closed room', and the very earliest form of camera was just that. It was, in fact, a darkened room with a tiny hole or lens in one wall which projected an inverted image of the scene outside

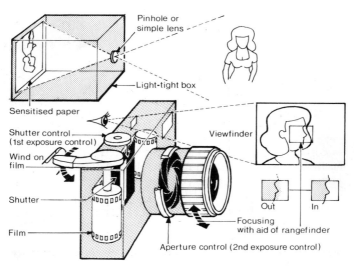

Pinhole or simple lens

Light-tight box

Sensitised paper

Shutter control (1st exposure control)

Wind on film

Viewfinder

Shutter

Out In

Film

Focusing with aid of rangefinder

Aperture control (2nd exposure control)

The modern camera works on the same basic principle as the earliest models, but includes a number of improvements to make photography easier, and applicable in a wide range of conditions

on to the opposite wall. This device was called a camera obscura and was used as long ago as the fourth century BC by the Greek philosopher Aristotle. However, it came into common use as an aid to artists in perspective drawing in the early nineteenth century.

The photographic camera is little more in essence than a scaled down version of the camera obscura with a piece of light sensitive material positioned opposite the lens to receive the image projected by the lens. A camera built to such a design would be perfectly serviceable if a little crude, and all the various controls and gadgets which are built into modern cameras of all types are simply embellishments on this fundamental design. In fact, if you look at a modern high quality studio camera designed to take sheet film, and ignore the various movements on the front and rear panels of the camera, you'll see that it's very little different from a simple dark enclosure with a lens at one end and a piece of film at the other.

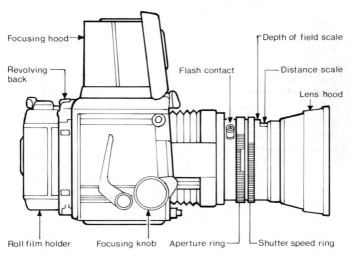

A compromise between full press camera facilities and portability is provided by some 6 × 7cm cameras with revolving back and built in bellows

The lens

Because it forms an image of the object at which the camera is pointed, the lens is perhaps the most important part of the camera. On its quality depends the sharpness of the image formed on the film at the other end of the camera; the better the lens, the better the image.

Many simple cameras have a fundamental lens made from a single piece of glass rather like a magnifying glass, but more expensive and complex cameras have lenses made up from several individual components, each of which is carefully designed to work in combination with the others to produce a needle sharp image over the entire area of the negative or slide. Some of these individual elements are positive and act as magnifying lenses, others are negative and act as reducing lenses, but when the whole combination is assembled the overall effect is that of a magnifying lens.

Every camera lens has two fundamental characteristics, focal length and aperture.

Focal length

When we were children, we all used a magnifying glass to project an image of the sun on to a piece of paper to start a fire. The distance at which you were holding the magnifying glass from the piece of paper is the focal length of that lens. In other words, the focal length of the lens is the distance between the lens and the paper at which an image of a distant object is reproduced sharply. In the camera, the piece of paper is, of course, replaced by a piece of photographic film.

Because of the way in which a lens works, the image formed on the film is upside down, but this doesn't matter because when the film is removed from the camera for developing and printing the negative can be used either way up.

The focal length of a lens is expressed in either inches or millimetres, the latter being by far the more common. Camera lenses usually have the focal length engraved on the

front of the mount, for example, $f = 80$ mm followed by a ratio such as 1:2.8 which indicates the maximum aperture of the lens, the other characteristic of a lens which I shall come to in a moment.

When a lens is mounted in a camera the distance between it and the film is the same as its focal length. This is to ensure that distant objects are reproduced sharply on the film. The distance between the lens and the film needs to be greater than the focal length when you're photographing objects which are closer to the camera.

On all but the very simplest cameras you can change the distance between the lens and the film to focus on objects at various distances from the camera. This is usually achieved by turning a focusing ring on the lens which is calibrated in feet or metres or, in simple cameras, with symbols representing portraits, distant scenes, groups, and so on. On many cameras you have to measure or guess the distance between the camera and your subject and set this on the focusing scale. But on more advanced cameras there's usually some form of focusing screen or rangefinding device to help you to focus accurately.

The range over which most camera lenses will focus is from 3 feet (1 metre) on cameras such as compact 35 mm models or 18 inches (0.5 metre) on most single lens reflexes, up to infinity.

A certain range of distances either side of that actually focused on is reproduced sharply on the negative or slide and is called the depth of field. This varies with the size of the lens opening and this characteristic is made use of in very simple cameras which have fixed focus or non-focusing lenses. These simple lenses are mounted in the camera at a distance slightly larger than the focal length away from the film and enable a range of distances from about 6 or 7 feet (2 metres) to infinity to be recorded reasonably sharply.

The focal length of the lens, and therefore its distance from the film, governs the size of the image on the film. For example, a lens with a focal length of 100 mm will produce an image twice the size of that produced by a lens of 50 mm focal length. The amount of this image that you actually use will

depend on the size of picture your camera takes. If, for instance, you're using a 35 mm camera, you'll take an area roughly 1 × 1½ in (24 × 36 mm) from the image, but if you're using a 6 × 6 cm twin lens reflex you'll take an area 2¼ in (60 mm) square from the image. So, obviously, for a lens of any given focal length you'll get far more in your picture with a large format camera than with a small format one. For this reason, the normal focal length lens varies according to the film or negative size and is roughly equal to the diagonal of the negative size. In other words, the normal lens for a 35 mm camera is between 40 and 55 mm in focal length, that for a 6 × 6 cm camera is roughly 80 mm in focal length, while that for a 5 × 4 in sheet film camera is about 150 to 180 mm.

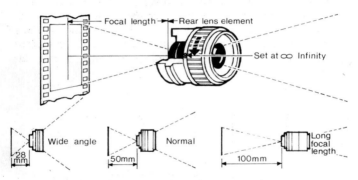

The focal length of a camera lens determines the size image it produces. On one film size, the shorter the focal length, the wider the angle of view

By using a different focal length for each negative size, roughly the same amount of the subject is recorded in each case, so that if you make a print from the whole of each negative, the pictures will be more or less the same, given the difference in picture proportion.

With cameras that allow you to remove the lens from the body, you can fit alternative lenses with different focal lengths. This means that you can alter the size of the image on the film to produce a different effect from that given by

the standard lens. If, for example, you fit a lens with a focal length shorter than that of the standard lens the size of the image on the film becomes smaller but you get more into your picture. On the other hand, if you fit a lens with a longer focal length than normal the image size becomes larger but you get less in the picture. There is much more about interchangeable lenses in the next chapter.

Lens aperture

The other basic characteristic of a camera lens is its aperture. This is simply the focal length of the lens divided by its diameter. So if, for instance, a 50 mm lens has a diameter of 25 mm, its aperture will be $f/2$. Because of the way in which aperture numbers are determined, the larger diameters have the smaller numbers. For example, $f/2$ is a larger diameter aperture than $f/8$ and therefore allows more light into the camera.

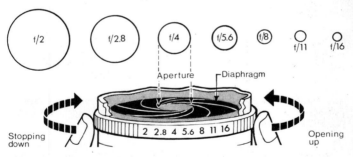

The lens aperture is calibrated in f/numbers. Each one passes exactly half the light that comes through the next largest on the scale

The very simplest cameras have lenses of fixed aperture, usually about $f/8$, but more advanced cameras have lenses with adjustable apertures. These may take the form of a lever indicating a weather symbol such as a bright sun or a dark cloud. On fully adjustable cameras, though, the aperture is

usually controlled by a ring on the lens which can be set to any one of a series of numbers. The ring adjusts a set of very thin metal leaves which are specially shaped to form a hole in the centre of the lens. As the ring is turned the hole becomes larger or smaller.

This series of numbers starts at the *f*/number representing the maximum aperture of the lens and carries on to the minimum aperture at which the lens is capable of being set. The series follows the sequence 1, 1.4, 2, 2.8, 4, 5.6, 8, 11, 16, 22, 32, 45 and the series on any particular lens may start and finish at any of the numbers within the series. For example, a typical 50 mm lens for a 35 mm single lens reflex may start at *f*/1.4 and finish at *f*/16. Occasionally a lens may have a maximum aperture which is not included in the series above – *f*/1.8 or *f*/3.5, perhaps. This simply means that the maximum aperture of the lens is between the main divisions.

Each aperture in the above series allows half as much light to be transmitted by the lens as the previous number. For instance, *f*/8 allows half as much light to enter the camera as

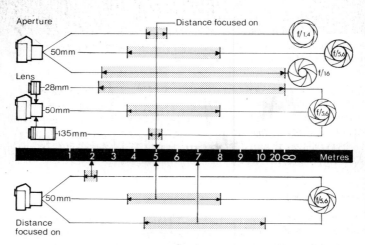

The amount of the subject pictured really sharp is called the depth of field. It depends on the lens aperture, focal length and focus distance

22

A wide lens aperture allows an out-of-focus foreground to surround a sharp distant subject (Graham McEune)

$f/5.6$ and $f/16$ allows a quarter as much light to enter the camera as $f/8$. So the larger the f/number the smaller the amount of light allowed to pass through the lens into the camera. This is one of the two main functions of the aperture control on an adjustable camera. The other is to control the depth of field.

Depth of field

The other effect of the lens aperture is in controlling the depth of field – the zone of sharpness – in your pictures. The larger the aperture, i.e. the smaller the f/number, the less the depth of field. So the depth of field is greater at, say, $f/11$ than it is at $f/5.6$.

Depth of field is also a function of image size; it is less with a large image size than with a small image size. As already pointed out, the image size of any object at a fixed distance from the camera is controlled by the focal length of the lens. This means that, in effect, the depth of field at any given aperture is less on a long focal length lens than it is on a short one. In other words, at any given subject distance the depth of field will be less at, for instance, f/8 on a 500mm lens than it is at f/8 on a 50mm lens, assuming that both are used on the same camera.

Most lenses on adjustable cameras have a depth of field scale engraved on the lens mount. This takes the form of a series of f/numbers on either side of the focusing mark and they enable you to check how much of your subject will be in focus. The simplest way to use it is to focus on your subject and read off the nearest and farthest points which will be sharp against the aperture you're using on the depth of field

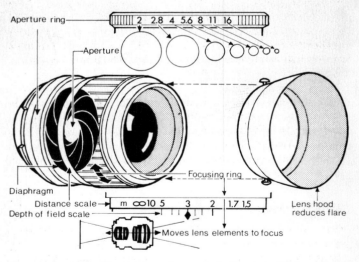

On a modern lens, the aperture ring controls the size of the aperture formed by the diaphragm, and thus the light reaching the film. The focus ring moves the lens to provide sharp focus in the right place

scale. But you can use the depth of field scale to get the maximum depth of field in your picture, too. Say, for example, you're taking a landscape with foreground interest and you want to have as much depth of field as possible at the aperture you're using which is $f/11$ on a 50mm lens. Instead of setting the focus control to infinity, set the infinity mark to the $f/11$ position on the depth of field scale. This will mean that the lens is set to about 20 feet (6 metres) and if you look at the other $f/11$ mark on the scale, you'll see that the nearest point to be sharp will be about 12 feet (3.5 metres). If the lens had been set at infinity the nearest point in focus would have been 20 feet (6 metres).

Shutters

The shutter on a camera is a means of controlling the length of time for which light is allowed to act on the film. On very early cameras the shutter was simply a lens cap which was removed from the lens to start the exposure and replaced to finish it. This crude type of shutter was perfectly adequate in those early days because films were not very sensitive and therefore long exposures were necessary; these could be timed by either counting off seconds or by checking with a watch.

However, with modern films, which are very sensitive, short exposures – often as short as $1/500$ or $1/1000$ second – are necessary. This means that some form of timing control, either mechanical or electronic, is essential in order to time these very short exposures accurately.

In modern cameras, two types of shutter are common, the diaphragm shutter and the focal plane shutter.

Diaphragm shutters

These are normally used in non-interchangeable lens cameras and operate in a similar way to the lens aperture diaphragm. They consist of a number of very thin metal leaves which are opened and closed mechanically to allow light to enter the camera.

This type of shutter is very quiet and vibration-free in operation and is relatively cheap to produce. It can also be used with electronic flash at all speeds. On the other hand, there are limits to the fastest shutter speed possible with the diaphragm shutter and ⅟₅₀₀ second is usually the upper limit.

Another problem with diaphragm shutters is that they take a definite amount of time to open and close and this can produce uneven exposure times over the aperture range of the camera. The shutter speeds are normally set for the

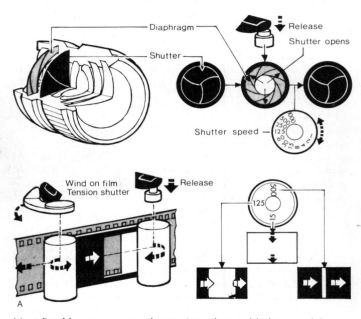

Most fixed-lens cameras and some interchangeable-lens models use a diaphragm shutter built in to the lens, or just behind it. The shutter opens for a preset time to allow the image to reach the film
A focal plane shutter lies just in front of the film. The horizontal type uses blinds which move from roller to roller, the vertical one two sets of folding blades. When the shutter is released the first blind moves across the film to let the image reach it; after a preset time, the second blind follows it to shut off the light again. At short speeds, the effect is of a slit crossing the film

maximum aperture of the lens therefore at a smaller aperture the effective exposure is greater.

Focal plane shutters

Because the diaphragm shutter is usually built into the lens assembly, it is not normally used on an interchangeable lens camera; a separate shutter would be required for each lens and this, of course, makes each lens very expensive. There are exceptions, though; most studio cameras and some large format single lens reflexes are fitted with diaphragm shutters. But practically all small format cameras with the facility for interchangeable lenses are fitted with focal plane shutters.

Focal plane shutters operate rather like two window roller blinds moving one after the other at a constant speed. The shutter speed is determined by the width of the gap between the two blinds and the film is therefore exposed in strips. The blinds are usually made of either rubberised material or extremely thin titanium foil.

This type of shutter has two very big advantages over the diaphragm shutter. Firstly, since the blinds move at a constant speed and only the gap between them is changed, the shutter tends to have better accuracy than a diaphragm shutter. And secondly, again as a result of changing the width between the two blinds, it is possible to produce a wider range of speeds with a higher upper limit.

But there are disadvantages, too. The focal plane shutter is rather noisier than the diaphragm type and tends to produce more vibration which can give rise to camera shake; and because the film is exposed in strips rather than all at once, electronic flash can only be used at the lower shutter speeds – $\frac{1}{60}$ or $\frac{1}{125}$ second or slower. If you want to use flash at higher speeds you have to use special focal plane bulbs.

Shutter speeds

Different shutter speeds are built into adjustable cameras to enable you to select the one most suitable for the picture

you're taking. On compact 35 mm cameras there are, perhaps, four or five shutter speeds but on more advanced cameras there are considerably more – up to ten or eleven on the top 35 mm SLR cameras.

Shutter speeds are in the series 1, $\frac{1}{2}$, $\frac{1}{4}$, $\frac{1}{8}$, $\frac{1}{15}$, $\frac{1}{30}$, $\frac{1}{60}$, $\frac{1}{125}$, $\frac{1}{250}$, $\frac{1}{500}$, $\frac{1}{1000}$ second and are usually marked with just the denominator – 1, 2, 4, and so on. Each successive shutter speed allows the light entering the camera to act on the film for half the time of the previous speed. For example, a shutter speed of $\frac{1}{60}$ second allows the light to act for half as long as $\frac{1}{30}$ second.

The shutter speeds are used in conjunction with the aperture f/numbers to control exposure. You can use any combination of shutter speed and aperture to produce your exposure as long as you remember to move to the next lower f/number if you change to the next higher shutter speed. So you can, for instance, use $\frac{1}{30}$ second at f/11, $\frac{1}{60}$ second at f/8, $\frac{1}{125}$ second at f/5.6 and so on.

Generally speaking, you would choose a high shutter speed – $\frac{1}{125}$ to $\frac{1}{1000}$ second – for action photographs where the subject is moving at a fairly high speed, and a slower shutter speed – anything from 1 second to $\frac{1}{125}$ – if the subject is stationary or moving very slowly and you wanted to use a small lens aperture to give maximum depth of field.

Viewfinders

The purpose of a viewfinder is to show you exactly what you'll get on your film when you press the shutter release button. Very early cameras used a simple form of wire viewfinder which was a frame made out of thin wire the same size as the negative and fixed to the front of the camera with a small peep-hole for sighting fixed to back of the camera. This type of viewfinder was reasonably accurate and has been superseded simply because less cumbersome methods have been found to do the same job.

Selecting a short (high) shutter speed such as $\frac{1}{1000}$ second as here, allows moving subjects to be frozen in mid-action (Robert Ashby)

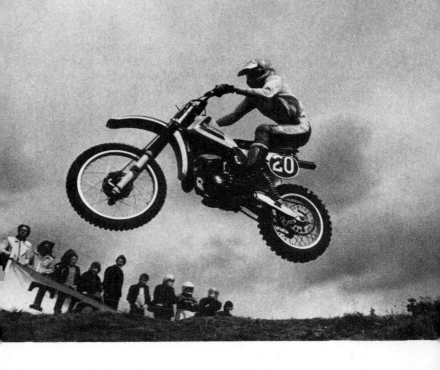

Optical viewfinders

This is the simplest type of viewfinder in common use today and is fitted to all fixed lens cameras. It consists of a small optical system mounted within the bodywork at the top of the camera with an eyepiece at the rear giving a direct view of the subject. Some of these optical viewfinders – which are known as bright frame finders – have a suspended frame within the viewfinder which indicates the negative area but also shows a small amount of the subject's surroundings so that you can see what is just outside the negative area and move the camera slightly if you want to. This type of viewfinder is particularly good for action shots because it enables you to anticipate when the subject is about to enter the picture frame.

29

One problem with this simple optical viewfinder is that the area shown by the finder tends to change slightly if you move the position of your eye. So unless you carefully check the viewfinder image with the negative image you're never quite sure exactly what will be in your picture and what will be out.

Another problem is that because the viewfinder is slightly above and to one side of the lens, it shows a slightly different view from that which the lens sees. This is called parallax error and while it is not important for distant subjects it can create problems for close work.

Rangefinder/viewfinders

A development of the simple optical viewfinder fitted to simple cameras is the combined rangefinder and viewfinder which is fitted to a great many non-reflex 35 mm cameras. It's rather like the simple optical finder except that it has a small area in the centre – often tinted – in which can be seen a double image. As you turn the focus control on the lens, the double image converges and becomes superimposed at the point where the subject is sharply focused. The viewfinder also has, usually, a bright line frame to show the limits of the negative area and often in interchangeable lens 35 mm cameras there are several of these bright line frames corresponding to the image area with various focal length lenses.

This type of combined rangefinder and viewfinder is very quick and easy to use, even in dim lighting conditions, but it is rather limited in its application. For example, it's not suitable for close-up work or for long telephoto work. I shall deal more fully with rangefinders a little later.

Viewing screen

The very oldest type of viewfinder for a camera was the focusing screen which was a part of every plate camera. This type of finder is still in use today on sheet film studio cameras and produces an image which is upside down and is viewed

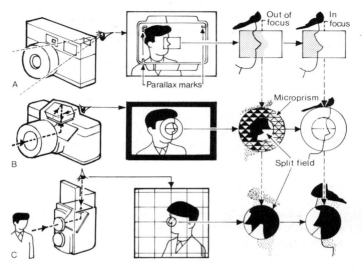

Viewfinders show what the camera will picture. A. An optical finder is rather like a tiny telescope. It may incorporate a bright-line frame to the picture area and a rangefinder spot to show sharp focus. B. A single-lens reflex forms an image through the main lens via a mirror. This shows the content and focus of the picture whatever lens is fitted. A central focusing aid is usually included in the focusing screen . C. A twin-lens reflex forms its viewing image through a second lens. The screen, which may also have a focusing aid, is usually viewed directly at waist level

from underneath a black focusing cloth. It is, therefore, the least convenient to use but the most accurate because it shows exactly what you'll get on your film and you can see exactly the effect produced by stopping down the lens or changing the focus.

The viewing screen has been adapted for more convenient use in the modern single lens reflex and twin lens reflex cameras. In this case the light entering the camera is turned through 90° by a mirror behind the lens and is directed on to a viewing screen in the top of the camera. This can be viewed by looking down at the screen holding the camera at waist

31

level or through a special device called a pentaprism which corrects the viewing screen image so that it appears upright and right way round when you view it at eye level. This is the most common type of viewfinder in use on more advanced cameras today.

Film mechanism

It is most important that no matter what type of camera you use the film is accurately positioned to receive the image when you press the shutter release. In all cameras except the sheet film studio camera, the film is in the form of a long roll which will take anything from 10 to 72 exposures. The film passes from a roll or cassette in one side of the camera, across the film gate – where it is held accurately in position by a pressure plate – and on to a take-up spool in the other side of the camera.

The film gate is where the film is actually exposed to the image produced by the lens, so it is most important that the pressure plate holds the film perfectly flat at this point.

After you've taken each picture, the film must be wound on so that an unexposed piece of film is in position ready for

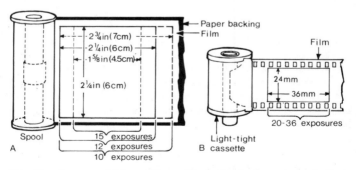

Two film sizes are widely used by enthusiastic photographers. A. Size 120 roll film offers a choice of image sizes, depending on the camera. B. 35 mm (135) is more convenient, offering more pictures per cassette, but has a much smaller image size

the next picture. Virtually all roll film and 35 mm cameras are fitted with an automatic film counting mechanism which allows you to wind the film on just enough for the next exposure and no more. This is normally interlocked with the shutter release mechanism to prevent you taking more than one picture before winding the film on. So you can't press the shutter release button twice without winding on the film and you can't wind on the film without pressing the shutter release button. In this way, the camera largely prevents wasted film by having either unexposed frames or double exposed frames.

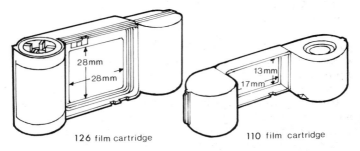

126 film cartridge 110 film cartridge

Two cartridge-loading film formats are available – used mainly for snapshot cameras

On early roll film cameras a small red window at the back was used to display the frame number of the film which was printed on the film backing paper. These have now largely disappeared, except on Instamatic cameras where a clear window is provided, to be replaced by a mechanical counting device which displays either the number of frames exposed or the number left on the film. When you open the back to insert a new roll or cassette of film the counter automatically resets itself to zero.

In most cases, when you wind on the film, the action also tensions the shutter ready for the next exposure.

With sheet film cameras, each picture is taken on an individual sheet of film which is held in a light-tight film holder and inserted in the back of the camera immediately

before exposure. A slide in front of the film must, of course, be removed first to uncover the film ready for the exposure. With this type of camera it is not possible to interlock the shutter and the film mechanisms to prevent double exposure or blank film, so you need to keep your wits about you much more when using a sheet film camera than when using other types.

3

Lenses .

The standard lens fitted to your camera when you buy it is perfectly adequate for a large proportion of the photographs you're likely to take, to begin with, at least. That's why the camera designers have settled on that particular lens as being the most useful for general purpose photography. However, it is something of a compromise.

Generally, the standard lens, as it's known, has an angle of view of around 50°, which is roughly equal to that of the human eye. This means that pictures taken with the standard lens will come out more or less as you saw the original subject, and for most straightforward pictures this is the kind of result you're likely to want. The standard lens will adequately cover a whole range of picture-taking situations from broad landscapes to half length portraits of people, and on 35 mm single lens reflexes, the standard lens will usually focus to at least as close at 18 in (0.5 m) to enable you to take pretty good close-ups of large flowers and the like. All of which shows why the standard lens is so useful.

However, there are situations with which the standard lens simply cannot cope. For example, with the standard lens, if you want to get the image of your subject larger on the negative or slide, you have to move closer to the subject. And if you want to get more of your subject in you have to move further away from it. This is fine as far as it goes, but there are times when it's simply not possible to move closer to, or further away from, your subject. Consider a shot of a stately home situated on the far side of a lake from where you're

35

standing. You simply cannot move closer to the building because of the lake, so you're forced to take a shot with your standard lens and then enlarge a small part of the negative to make your print. And if you're using colour slide film there's even less you can do about it. On the other hand, if you're taking a photograph of a very wide building you need to be able to move fairly well back from it in order to get it all in. But if there's another building behind you, you simply can't do this and so you have to make do with a shot of only part of the building or change your angle which will then accentuate the perspective of the building. These two situations are typical of instances when the ability to fit a different lens to your camera would be most useful.

In the first situation a long focus or telephoto lens would increase the image size of the building within the negative frame, effectively bringing the building closer to you. And in the second situation a wide angle lens would enable you to

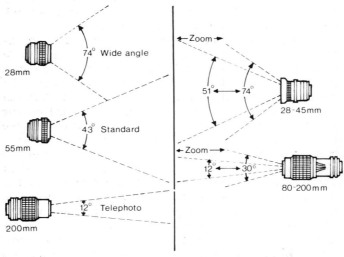

The popular 35 mm SLR cameras are designed to be used with a range of lenses. Conventional 'prime' lenses have fixed focal lengths; but zoom lenses, offering a range of focal lengths, are becoming increasingly popular.

get all of the building in your negative, so effectively moving the building further away from you. But interchangeable lenses can do more than just change the image size within the picture as we shall see a little later.

Fitting different lenses

All sheet film studio cameras, most single lens reflexes, a few coupled rangefinder cameras, and just one twin lens reflex have the facility to accept lenses other than the standard one supplied with the camera. There are several different ways of fitting alternative lenses to a camera body, depending on the particular type of camera. The oldest, and probably simplest, form is that used on sheet film studio cameras where each lens is fitted to a separate square lens board which clips securely into the front panel of the camera, As each lens contains its own shutter, there are no complicated mechanical linkages in this type of interchangeable lens system.

An adaptation of this simple system is found on the Mamiyaflex twin lens reflex – the only TLR currently in production to accept interchangeable lenses. In this case there are two lenses mounted on a single lens board. The bottom lens incorporates a diaphragm shutter, as in the sheet film type, and the second, upper, lens is a viewing lens. The panel carrying these two lenses clips on to the front of the camera in a similar way to a sheet film camera lens panel.

By far the majority of interchangeable lenses are fitted to their appropriate cameras by means of a screw thread or bayonet mount. A decade ago, the most common form of mount was the screw thread. On the back of the lens mount was a screw thread, usually 39mm or 42mm in diameter, which screwed into a threaded flange on the front of the camera body. To change lenses you simply unscrewed one lens from the body and screwed another in its place. This type of mount had the advantage of being simple, cheap to produce, and hard wearing, but it also had a few drawbacks. Firstly, it was comparatively slow in use since the lens needed

to be turned two or three complete revolutions to unscrew it and the alternative lens had to be turned through two or three complete revolutions to be screwed in. Secondly, it was found to be difficult to produce mechanical linkages sufficiently accurate to be used with full aperture metering systems and aperture operating systems with a screw thread mount. Since the trend in the best single lens reflex cameras, especially 35 mm SLRs, is towards more and more automation of exposure, the screw thread interchangeable lens system has slowly fallen out of favour and only a few of the relatively simple and inexpensive SLRs continue to use it.

While the use of screw thread interchangeable lens systems has declined, the bayonet mount system has become more and more popular. It is much faster in use than the screw thread mount and since the lens is located precisely in the body every time, it is much easier to provide accurate meter and aperture coupling linkages.

An early criticism of bayonet mounts was that, because there is no standardisation of the mount, you were virtually forced to use only those lenses produced by the manufacturer of the camera. However, this problem has been overcome to some extent by the increasing number of lenses produced by independent lens manufacturers. These lenses are invariably available with different mounts to enable them to be used with virtually any SLR on the market. Indeed, many of the independent lenses are available with interchangeable mounts, so that if you change from one camera to another make you don't need to get rid of your lenses and buy new ones; you can simply buy new mounts to suit the new camera.

One criticism often levelled at bayonet type interchangeable lens mounts is that they tend to wear with heavy use and this affects the seating of the lens on the camera body. While

Interchangeable lenses enable you to control the size of the image on the negative. All the following shots – taken with a Praktica SLR – were taken from the same position using the following focal lengths: 20 mm, 28 mm, 35 mm, 50 mm, 85 mm, 135 mm, 300 mm, 500 mm (Derek Watkins)

this may be true as far as professional usage of a camera is concerned, when the lens may need to be changed perhaps hundreds of times a week, it is of no real concern to the amateur photographer who uses his camera far less than a professional does. In fact, it's not really a serious problem for the professional because by the time a lens mount is worn sufficiently to cause sloppiness of fit, the camera is likely to be worn out anyway!

Interchangeable lenses

If you look at the brochures produced by any of the leading single lens reflex manufacturers, you'll see that there is an extremely wide range of different lenses available to fit the camera body. These vary in focal length from as short as 6 or 8 mm up to 1000 or even 2000 mm and cover a variety of lens types from fisheye to extreme telephoto. In addition to these fixed focal length lenses there's likely to be at least one zoom lens which has a focal length variable between two limits plus one or more so-called macro lenses which enable you to move in really close to your subject without the need for special close-up accessories.

By far the widest range of interchangeable lenses is available for the 35 mm single lens reflex type of camera. Larger format SLRs also have quite a wide range of lenses available for them, but not as wide as the 35 mm size. Coupled rangefinder cameras are usually limited to a fairly narrow range of alternative lenses, as is the sole twin lens reflex which accepts interchangeable lenses. Let's take a look at the different types of interchangeable lens available, starting at the shortest focal lengths.

Fisheye lenses

The fisheye lens became popular during the mid-1960s when a few advertising photographers and photojournalists used it to produce pictures which had an enormous impact on the

viewer. This impact was given by the incredibly wide angle of view that this type of lens achieves. Incidentally, this type of lens is called the fisheye, not because the angle of view resembles that of a fish's field of view, but because the front element of the lens bulges right out and looks exactly like a fish's eye.

There are two basic types of fisheye lens – full frame and full image. The full frame fisheye produces an image which completely fills the negative or slide while the full image types gives a circular picture in the centre of the negative or slide surrounded by an area of unexposed film. The circular image type of fisheye for use with a 35mm single lens reflex has a focal length of around 6 to 8mm and an angle of view of around 180° to an amazing 220°, while the full frame fisheye has a focal length of about 15mm and an angle of view of 180° from corner to corner of the picture. This type of fisheye is probably the more useful of the two as it enables the conventional rectangular picture to be produced.

Both types of fisheye lens have one basic characteristic. They produce a curvilinear image as opposed to the recti-linear one produced by most other lenses. Quite simply this means that straight lines, instead of appearing as straight lines as they do with a rectilinear lens, appear as curved lines and the further the line is from the centre of the image, the more curved it appears to be. In fact, with the full image type of fisheye a line appearing at the very edge of the picture becomes completely circular. This, of course, doesn't happen with the full frame fisheye because the picture is rectangular rather than circular.

When the fisheye lens first became popular, it certainly created a lot of interest, simply because it produced images which were so different from those we were all used to. The problem was that everyone jumped on the bandwagon and fisheye pictures quickly became quite a common sight with the result that they degenerated into just another gimmick. This is still largely true today and, although an occasional fisheye picture can have a great deal of impact, it's not the kind of lens that you want to use very often. For this reason, and because a good fisheye lens is very expensive, I would

suggest that a fisheye lens should be well down your list of priorities when it comes to buying additional lenses for your camera system. You'd do far better to spend the money on a really first class wide angle or telephoto lens or possibly on a second camera body to enable you to shoot in both black and white and in colour without having to change films.

If you feel that you really must have a fisheye, then it's worth trying one of the fisheye adapters which are now available. They give a similar effect to a proper fisheye but at a considerably reduced price.

Wide angle lenses

This class of lens covers a range of focal lengths between about 17 mm and 35 mm for 35 mm cameras and from about 40 mm to 60 mm for large format SLRs. For the 5 × 4 in sheet film camera the wide angle lenses available range from about 60 mm to 90 mm. This range of wide angle lenses has angles of view ranging from 104° to about 66°.

Since the biggest range of wide angle lenses is available for 35 mm SLRs I shall concentrate on this particular type of camera, mentioning the other formats only where they're applicable.

Super-wide angles

The very shortest focal length lenses ranging from 17 mm to 24 mm and having angles of view from 104° to 84°, are usually called super-wide angles or extreme wide angles. In some ways, these are comparable to fisheye lenses in that they're likely to be useful for the occasional shot but are not the kind of lenses you'd want to use frequently, simply because the

These shots show the difference in results between a conventional extreme wide-angle and a fisheye lens of similar focal length. *Top:* 17 mm Tamron wide-angle. *Centre:* 16 mm Sigma fisheye, both on Olympus OM–1. A shot taken from the same position with a 50 mm lens is included for comparison (Derek Watkins)

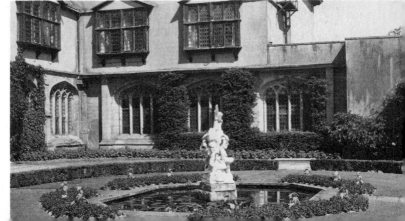

angle of view is so large that there is inevitably some distortion towards the edges of the picture which shows itself as a stretching of objects near the edge of the frame.

However, if you want to take a lot of architectural photographs, a super-wide angle lens will probably be extremely useful and of the focal lengths available I would suggest that a lens of 20 or 21 mm focal length would probably be the best buy; a 17 or 18 mm lens is a little too wide and a 23 or 24 mm lens is perhaps a little narrow for this type of work. In fact I would be tempted to include the 23 and 24 mm lens in the next class – normal wide angle lenses.

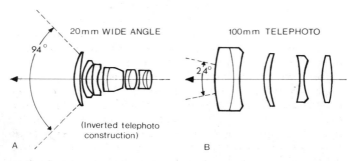

Optical designers working with computers calculate the simplest construction that can provide good quality images with different angles of view

For larger format SLR cameras – 6 × 6 cm and 6 × 7 cm – the focal lengths giving extreme wide angle results are 40 mm and 50 mm. They give similar results on these larger formats to those obtained on 35 mm using a lens of about 21 mm focal length.

Normal wide angles

Lenses for 35 mm cameras with focal lengths from 24 mm to 35 mm fall into the class of normal wide angle lenses. These

44

are generally much more useful than their super-wide angle brothers. They give a considerably wider angle of view – from 84° to 63° – than the standard lens, but without the problems of distortion near the edge of the picture. Of the range of normal wide angle lenses, I would personally consider the 28 mm focal length to be by far the most useful. It gives a considerable increase in angle of view over the standard lens and enables you to achïeve a wide range of creative effects. The 35 mm focal length lens is, in my opinion, too long to be of any great value as a wide angle lens. In fact a great many photographers now use the 35 mm lens as their standard rather than the 50 mm lens. And the 24 mm wide angle is perhaps a little too wide for general use, and it is getting to the point where edge distortion is beginning to creep into the picture. Also, the 24 mm lens tends to be considerably more expensive than the 28 mm model.

One thing worth bearing in mind when buying a wide angle lens is the maximum aperture. Generally speaking, wide angle lenses tend to be used at fairly small apertures to ensure maximum depth of field (as I pointed out in the previous chapter, depth of field is greater on a wide angle lens than on a standard or long focus lens at any given subject distance) so there seems little point in buying a wide angle lens with a wide maximum aperture costing in some cases as much as twice the price of one with a smaller maximum aperture. Several SLR manufacturers now offer a choice of two apertures in lenses of certain focal lengths.

Normal wide angle lenses for 6 × 6 cm and 6 × 7 cm SLRs have focal lengths of 50 to 60 mm. One interesting lens that's produced by a few 35 mm SLR manufacturers is the 35 mm Perspective Control lens. With this device you can change the position of the lens relative to the film in order to move the image slightly within the picture frame. This is most useful when you're taking architectural pictures since it enables you to raise the lens slightly to get the top of a building into the picture without having to tilt the camera which would cause the verticals of the building to converge towards the top.

Telephoto lenses

Lenses with focal lengths from about 85 mm up to 1000 mm or even more fall into the category of long focus or telephoto lenses. They do exactly the opposite to what wide angle lenses do. In other words you get less in your picture and the effect is that of moving closer to your subject.

The angles of view of these lenses range from 29° to 2.5° or even less. And for large format SLRs the equivalent focal lengths are 120 mm to 1000 mm, although the 1000 mm lens on a 6 × 6 cm camera has an angle of view of 4.5°, which is roughly equivalent to a 600 mm lens on a 35 mm camera.

This vast range of telephoto lenses can be conveniently broken down into three classes – short telephotos, medium telephotos, and long telephotos.

Short telephotos

If you're interested in portraiture and intend to make this branch of photography one of your major fields of activity, a lens with a focal length of around 85 to 100 mm for a 35 mm camera or 120 to 135 mm for a larger format SLR will be perfect for your needs. In fact many portrait photographers use a lens within this range as their standard rather than the 50 mm lens for 35 mm cameras or 80 mm for 6 × 6 cm. The reason for this is that it enables you to shoot a head and shoulders portrait from a distance of about 6 feet (2 metres) which is far enough away from the subject to avoid distortion yet the image is big enough to fill the negative or slide. In most cases a lens of this focal length is roughly the same physical size as, or only slightly bigger than, the standard lens and in most cases the maximum aperture is about the same as that of a standard lens – around $f/2$ for a lens for a 35 mm camera. This relatively large maximum aperture enables you to work in low light levels without having to use unduly slow shutter speeds while the relatively shallow depth of field means you can focus accurately on the subject and throw the background out of focus.

Lenses in this short telephoto category are useful in other aspects of photography, too. One of the main faults in photographs, especially those taken by beginners, is that the photographer includes too much in the picture. The short telephoto lens of 85 to 100 mm focal length can help to solve this problem, because it helps to concentrate interest on the subject itself and cuts out much of the insignificant detail surrounding the subject.

Generally speaking, the short telephoto is a very easy lens to use. It doesn't produce the effect of extremely compressed perspective as longer focal length lenses do, yet it helps to tighten up your pictures and can be a big help in improving your sense of composition.

Medium telephotos

Perhaps the most popular telephoto lens with 35 mm camera users is the 135 mm focal length with its angle of view of 18°. The equivalent lens for a larger format SLR is about 250 mm focal length. The 135 mm lens is at the bottom end of the medium telephoto range which extends to about 200 mm with an angle of view of 12°. A 350 mm lens gives a similar effect on a large format SLR.

The effects produced by lenses in this range of focal lengths are a flattening or compression of perspective caused by taking a comparatively narrow angle of view from a considerable distance, and a relatively shallow depth of field which helps to concentrate interest on the subject.

Because the lenses in this range give fairly large magnification of the image compared with that given by the standard lens, they are rather more tricky to use than the short telephotos. Generally, you need to use a rather faster shutter speed because any slight movement of the camera or the subject will show up in a far more pronounced manner on the negative than it would if you were using a shorter focal length lens. A good rule of thumb is to use a shutter speed at least as short as the reciprocal of the focal length lens. In other words, if you're using a 200 mm lens, use a shutter

speed no slower than ½₀₀ second – the standard shutter speed to use in this case would be ½₅₀ second.

Most lenses in this medium telephoto category have maximum apertures rather smaller than those in the shorter category; anything between f/2.8 and f/4.5 is normal. This means that, in combination with the shutter speed restriction to eliminate any possibility of camera movement, you tend to need a rather faster film speed than usual when shooting with a medium telephoto. Or alternatively, you need to use the camera on a steady support such as a tripod rather more frequently than you would otherwise need to.

Personally, I think that the 135 mm telephoto is rather too long for portrait work. It means that you have to work at a distance of 8 to 10 feet (2.5 to 3.5 m) from your subject which in an indoor situation is difficult and inconvenient. But for landscape work the 135 mm telephoto is difficult to beat. And for sports photography a 180 or 200 mm lens is excellent, since it combines the ability to bring the action close to you while still being reasonably easy to handle. In fact these two lenses at the top end of the medium telephoto range are about the longest that is is practical to hand hold, although some of the latest lightweight, compact SLRs have lenses of 300 mm focal length which are small and light enough to be hand held without inducing camera shake. However, to be on the safe side, I would suggest using the camera on a good steady tripod when it's fitted with a telephoto lens around 200 mm in focal length. That way you're freed from the restriction of having to use a shutter speed of ½₅₀ second or faster and you can shoot with speeds as slow as ⅓₀ second if necessary, as long as the subject is stationary, of course. If you don't have a tripod, you can usually improvise some form of support for the camera when fitted with a long lens, such as a wall or the top of a gate or simply holding the camera pushed against the trunk of a tree. While not as good as a tripod, this makeshift type of support will at least be an improvement on trying to just hand hold the camera.

A medium telephoto lens, or better a telephoto zoom, allows the subject to be framed just right (P. J. Mills)

Long telephotos

Lenses with focal lengths of 300 mm up to 1000 or 2000 mm for 35 mm cameras fall into the category of long telephotos and are really specialist lenses which have little place in an outfit for general photography. These long lenses are usually very heavy and bulky and have maximum apertures around $f/4.5$ for the 300 mm lens to as small as $f/11$ or $f/16$ for the 1000 and 2000 mm lenses. Because of this it is essential to use the camera when fitted with a long telephoto lens on a really steady tripod. With an angle of view as small as 8° to 2.5° or 1.25°, the slightest movement of the camera or subject will result in a highly blurred image.

Another problem that's often encountered when using very long telephoto lenses is caused by the atmospheric conditions which can produce pronounced haze and softening of contrast even when the weather conditions are apparently clear. With black and white photograhy this effect can be minimised by the use of an orange or red filter, but if you're shooting colour there's little you can do about it.

Very long telephoto lenses find their biggest use in wild life photography and for shots of fast action sport when you're separated from the action by a considerable distance, such as at a motor race, for example.

Long telephoto lenses are extremely expensive and unless you're intending to specialise in wild life photography or some other similar aspect, it would be difficult to justify the cost of such a lens.

An interesting recent development in long telephoto lenses is the mirror lens. This, as its name implies, incorporates high quality mirrors as part of the construction and the light rays entering the lens are bent backwards and forwards inside the lens before entering the camera. In this way, it's possible to make a very compact lens with a relatively long focal length. The problem with this type of lens, though, is that it has a fixed aperture, usually at around $f/8$ or $f/11$, so it's impossible to control the depth of field by stopping the lens down and to control the light entering the camera you have to use special neutral density filters instead of the usual

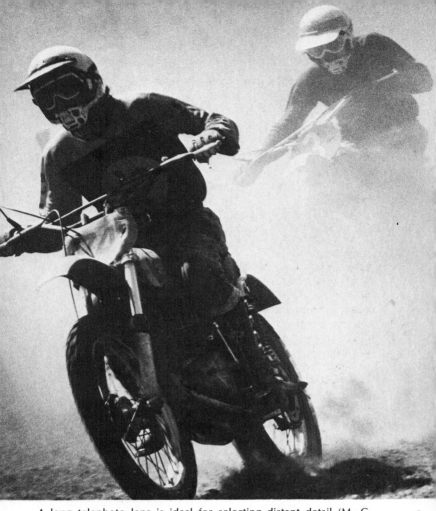

A long telephoto lens is ideal for selecting distant detail (M. C. Dobson)

aperture diaphragm. Or, of course, you can use longer or shorter shutter speeds. Another problem is that this type of lens, although being much easier to handle than a conventional long telephoto, is even more expensive.

51

Zoom lenses

Perhaps the best answer to the problem of which telephoto lens to buy lies in the zoom lens. This type of lens has a variable focal length which enables you to change the angle of view by simply turning or sliding a collar on the lens barrel.

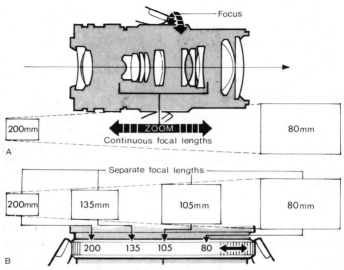

A. A zoom lens alters focal length by moving some groups of glass elements. B. Some lenses have a zoom ring, others a single zoom and focus control; but most show a range of intermediate focal length settings. 'Varifocal' lenses have to be refocused at each setting

Although the zoom lens has been used in the film and television industries for a great many years, it is a comparatively recent innovation in still photography. The most popular lenses are 70–150 mm, 80–200 mm, and 150–300 mm. Of these, my own particular favourite is the 70–150 mm because it's no bigger than a fixed focal length 135 mm lens and it covers a whole range of activities including portraiture, landscape and a certain amount of sports photography. A

52

good second choice would be the 80–200 mm lens, but I feel that the longer 150–300 mm zoom is more of a specialist lens which is considerably heavier and bulkier than the other two and therefore needs much more care in use.

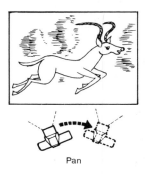

Pan

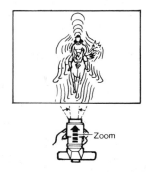

Zoom

To give an impression of movement, it is often worth making part of the picture blurred. Two ways are to swing the camera (pan) with the movement, or to alter the focal length of a zoom lens during a long exposure

Even more recent is the introduction of short focal length zoom lenses covering, in some cases, a range from moderate wide angle to short telephoto with a focal length range such as 35–85 mm and there's at least one zoom lens now which covers the range from 25–50 mm. But while the telephoto zooms are quite reasonable in price, the wide angle zooms, because of their more complex construction, tend to be very much more expensive.

One of the very big advantages of using a zoom lens is that you can frame a picture exactly as you want it by changing the focal length of the lens until the picture in the viewfinder is exactly right. This is particularly important when you're using colour slide films where it's difficult to modify the image on the finished slide. Another advantage is that you don't waste time changing lenses. And instead of having to carry perhaps three different lenses in your bag you can often replace them with just one zoom lens.

On the disadvantage side, the maximum aperture of zoom lenses tends to be around f/3.5 to f/4.5 and this can be a slight problem when working in low light conditions. But in my opinion the advantages far outweigh this one slight disadvantage.

Macro lenses

This type of lens is another comparatively recent innovation and is designed specifically for taking close-up pictures in addition to general photographic work.

Most macro lenses are designed for 35 mm SLRs and are available in focal lengths around 50 to 55 mm, although one or two are available at 90 to 100 mm.

The idea is that the focusing scale extends very much closer than on a normal standard lens, either by an extended normal focusing scale or by operating a lever to move one of the elements or groups of elements inside the lens, to permit very close focusing; close enough, in fact, to produce life-size or nearly life-size images on the negative or slide. The maximum aperture of this type of lens is usually in the range f/2.8 to f/4.5 and it is much larger and heavier in construction than normal 50 mm lenses, as well as being a lot more expensive. So again, the macro lens can be considered as a specialist lens rather than one for general purpose photography.

Many of the zoom lenses now available also have a so-called macro facility, although the closest distance possible to focus upon with this type of lens is not short enough to give a life-size image or anything near it, so the lens isn't really a macro lens at all. Pesonally, I'm not terribly fond of these zoom lenses with a macro facility. It seems to me that they're too much of a compromise because they're trying to do too many jobs and end up doing none of them particularly well. My own feeling as far as close-work is concerned is that it's much better to use either a specialist macro lens or extension tubes or bellows, or close-up lenses in conjunction with the standard lens for your camera because that way you'll produce much better results.

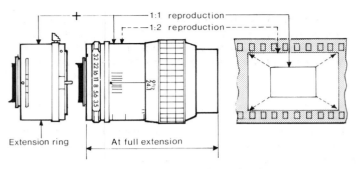

Extension ring At full extension

Close focusing or macro lenses are popular with SLR camera owners. They allow normal and close-up work with one lens. Most are supplied with an extension tube to let them focus even closer – usually near enough to reproduce subjects same size on the film

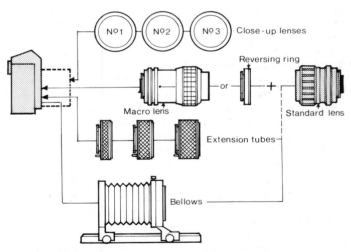

The simplest way to focus closer is to fit a supplementary lens. For really close work, though, the lens has to be moved further than normal from the film. A macro lens incorporates the facility, but a normal lens can be used on extension tubes or bellows. A ring that allows the lens to be reversed can give better image quality at high magnification

Which lenses?

The particular lenses you choose for your outfit will depend, like your choice of camera, on the kind of photography you do. For general purpose photography perhaps the most suitable range of lenses is 28 mm wide angle, 50 mm standard lens and 135 mm telephoto lens, although this telephoto lens could be replaced by a 70–150 mm zoom which will give you far more versatility, especially if you want to shoot portraits. If you're interested in architectural photography you may like to add a second wide angle lens to your outfit – a 24 or 21 mm, for example, while if you're interested in sports photography or wild life photography you may find that a 300 mm telephoto would be far more use to you than the 28 mm wide angle.

But as a general rule, I would suggest that you use just your standard lens to begin with and only buy an additional lens when you find that the standard lens won't enable you to get the kind of pictures you want. I've seen far too many newcomers to photography go out and spend many hundreds of pounds – if not thousands – on a camera and a whole range of lenses only to find very shortly that they're confused about which lens to use and find that they hardly use some of the lenses at all. This represents a waste of money which could have been put to far better use. So get to know one lens first and add to it as you feel necessary.

The lenses I recommended above are, of course, for 35 mm cameras. If you're using a larger format you'll need to use the equivalent lenses mentioned earlier in the chapter.

Teleconverters

So far in this chapter I haven't mentioned teleconverters for the simple reason that I'm generally not in favour of them. They are at best a compromise and a very poor compromise at that.

A teleconverter will multiply the focal length of your lens by 2 or 3 times, so that if you have a 100 mm lens and use it in

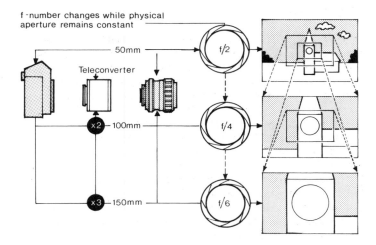

f -number changes while physical
aperture remains constant

Teleconverter

Instead of changing the whole lens, it is possible to fit a behind-the-lens converter to give a telephoto effect. Most double the focal length, but others alter it by a factor of 1.4, 2.5 or 3. As the light from a constant-size aperture is spread further, using a teleconverter changes the effective *f*/number by its magnification factor

conjunction with a 2× converter you end up with, in effect, a 200 mm lens. But, when you use the teleconverter, you reduce the maximum aperture of your lens by two or three stops depending on the power of the converter. So with the 2× converter on an *f*/4 maximum aperture lens the maximum aperture of the combination is reduced to *f*/8.

Also, if there are any faults in the basic lens, the teleconverter will tend to magnify them. However, having said that, the teleconverter can be a useful standby and will double the range of lenses that you have, but you must be prepared to put up with the inconvenience of a two or three stop loss in maximum aperture and a loss of image quality.

4

Film and format

Film is the fundamental raw material of photography. Without it there would be no negative or colour slide and no permanent picture – except in a few special cases which don't concern general photography.

The film you use in your camera can be one of two types – negative or reversal, and both are available as black and white or colour materials. Negative films reproduce the subject you photograph with all the tones reversed. In other words, where the subject was light in tone the negative will be dark, and where the subject was dark the negative will be light. In the case of the colour negative film the colours, too, are reversed. Yellow parts of the subject are blue in the negative, green parts are magenta in the negative, blue parts are yellow, and so on.

The negative is only an intermediate stage in producing a picture; it is used to make prints, either the same size as the negative or larger. During this printing process, the tones – and colours – in the negative are reversed again so that the final result shows the subject correctly.

Reversal films, on the other hand, produce a picture of the subject in its correct tones and colours, direct on the film in the camera. It is called reversal film because part of the process of producing the pictures is a reversal stage which converts an originally negative image into a positive one. Most of the reversal films currently available are colour which are used to produce colour slides for projection, but there are a few black and white reversal films around as well.

Reversal colour films are also used a great deal in sheet form – 5 × 4 in, 5 × 7 in and 10 × 8 in – by professional photographers to produce large slides (called transparencies) for reproduction in magazines and advertisements.

No matter what type of film you use in your camera, it has a number of basic characteristics – speed, grain, sharpness, resolution and contrast – each of which has a marked effect on the negative or slide produced. As the film speed increases so does the grain size, while sharpness, resolution and contrast all fall. Colour films also have two other characteristics – colour balance and colour accuracy.

Film speed

The speed of a film is a measure of its sensitivity to light and is expressed numerically as an ASA or DIN number such as 125 ASA or 22 DIN. ASA numbers are those given by the American Standards Association and DIN numbers are those given by the German Standards authority (Deutsche Industrie Norm). The two types of numbering are based on different scales and a conversion table is given. To avoid confusion I shall refer to film speeds only by their more common ASA values from now on.

Comparison between ASA and DIN film speeds			
ASA	DIN	ASA	DIN
6	9	100	21
8	10	125	22
10	11	160	23
12	12	200	24
16	13	250	25
20	14	320	26
25	15	400	27
32	16	500	28
40	17	640	29
50	18	800	30
64	19	1000	31
80	20	1250	32

The higher the ASA speed number of a film, the more sensitive that film is to light; in other words, the faster the film speed. In fact the speed is linked arithmetically to the ASA number. For example, a film with a speed of 400 ASA is twice as fast as one with a speed of 200 ASA and four times as fast as one at 100 ASA. This means that the exposure necessary with a 200 ASA film is half that needed with a 100 ASA film and twice that needed with a 400 ASA film. Films can be conveniently divided into three groups – slow speed, medium speed, and fast or high speed.

Slow films are those with speed ratings from 25 to 50 ASA and generally have the finest grain, the highest contrast and produce the sharpest images of all. The disadvantage with this type of film is the relatively long exposure necessary to produce an image. This means that you either have to use a slow shutter speed or a large lens aperture. If you need to use a small aperture you may have to fix your camera to a tripod to avoid movement during the long exposure time, but if you want to produce negatives of the highest possible quality, a slow film is the one to choose.

Medium speed films are the general purpose work-horses of photography. Their speed – ranging from 64 ASA to 200 ASA – is high enough to enable you to use a combination of reasonably fast shutter speed and middle of the range aperture, yet the grain, resolution and contrast characteristics are all good enough to produce high quality results. A medium speed film is the best to keep in your camera most of the time, changing it only when you want to produce pictures for which one of the other two types would be more suitable.

Fast films have speeds of 250 ASA and higher. They're the films to use when the light is poor, if you're shooting indoors without special lighting, and if you're taking pictures of fast moving subjects. The grain is more pronounced in a fast film while the contrast is lower and so is the resolution. But you can take pictures on a fast film when you've run out of shutter speeds or apertures with a slower one. Many photo-

A 6 × 6cm camera produces a smooth fine-grain image even on medium-speed film (P. Chan)

graphers use a fast film with a speed of 400 ASA as their standard, reasoning that they can always produce some sort of picture. It all depends on the kind of photography you do, but personally I prefer to stick to a medium speed film as standard on the grounds that the image quality will be better.

Contrast

Contrast is an expression of a film's ability to accept and reproduce differences in the subject brightness. A high contrast film will tend to record shadows at a deeper tone and highlights at a brighter tone than a low contrast film. For this reason, it is often best to choose a high contrast, slow film when lighting conditions are flat, and a low contrast fast film when conditions are bright and contrasty. Unfortunately, this is just the opposite of what you'd want to do, because the extra speed of a fast film would be more use when conditions are dull and lacking in contrast. However, if you progress to developing and printing your own films you can learn how to control the contrast of your negatives during development.

Grain

Every film you put into your camera consists of a transparent base coated with a so-called emulsion which consists of grains of light-sensitive silver salts suspended in gelatine. It is largely the size of these grains which determine the speed of the film. The larger the grains, the faster the film speed.

If you look at a negative or slide through a powerful magnifying glass, you'll see that the image is made up of these grains and that the effect is more pronounced with a

When fine detail and extreme sharpness are important, use a slow, fine grain film. This will often mean that you need to use a slow shutter speed, so it is best to fix the camera to a tripod (Derek Watkins)

fast film than with a slow one. As a result, it may not be possible to make big enlargements from your negatives on fast films without grain becoming obtrusive.

Sharpness

Sharpness is the film's ability to produce a clear, crisp edge between areas of different tone – assuming, of course, that the camera has been sharply focused on that edge. In general, slow films have a greater ability to do this than fast films, and there are special developers available to improve this edge effect still further on slow and medium speed films, giving an impression of even greater sharpness.

Resolution

This characteristic is often confused with sharpness and it is true that the two are, in many ways, similar, but resolution is the ability of a film to record fine detail clearly and accurately. A typical example is when photographing winter trees against the sky; a high resolution film will record every twig separately while a low resolution one will tend to record the whole as a soft, mushy area of tone. As with sharpness, slow films tend to have better resolution characteristics than fast films.

Colour films

As mentioned earlier, colour films have all the same characteristics as black and white films but with the addition of colour balance and colour accuracy, both of which suit the film to particular applications.

Colour balance

This fundamental characteristic determines whether the film is suitable for taking pictures in daylight or in artificial light and is built into the film during manufacture. Most films are available as type D or S for daylight use and as type A or L for use with studio tungsten lighting.

You can, however, use each type of film in both kinds of lighting as long as you fit a conversion filter to your camera when using it with the type of lighting for which it is not specifically designed. Without the filter, pictures taken in artificial lighting on daylight type film will have an overall reddish-orange colour and those taken in daylight on artificial light film will have an overall blue colour.

Colour accuracy

No colour film yet produced will record a subject accurately in its natural colours – it is just not possible within the limitations of the photographic process. So every colour photograph is very much a compromise as far as colour accuracy is concerned.

Colour is very much a question of personal taste, so the particular type of colour inaccuracy you prefer is your own choice. Some colour films tend to have a cool bias; that is to say they tend to produce pictures with a bluish colour, while others have a warm bias and produce slides with a yellowish-brown bias. Personally, I prefer the latter as I think it gives me better results with landscapes and buildings, which are the kind of pictures I mostly shoot.

The colour produced by any film can be modified to some degree by using filters as I shall describe later.

If you prefer to shoot colour negative films to produce prints, the colour balance of a particular film is of less concern than with colour slide films. This is because, when prints are made from the negatives, any colour bias can be corrected at that stage. Indeed, if the prints are made commercially this correction is carried out automatically as the negative is printed.

Film size and format

The film size and format of your pictures are governed by your choice of camera. If you have a 6 × 6 cm twin lens reflex, the camera will take size 120 roll film and will produce negatives and slides with a format of 60 mm (2¼ in) square.

Film size – or more precisely negative size – has a profound effect on the quality of your picture. All other things being equal, you'll get better results from a large negative than from a small one. If you think about that, it's pretty obvious. A large negative doesn't need to be enlarged as much as a small one to produce a given print size, so grain will be less obtrusive. Sharpness and resolution will be better, too.

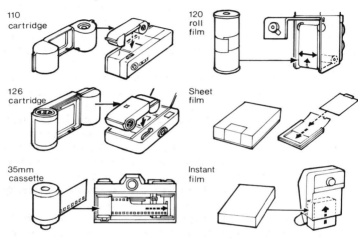

110 cartridge

120 roll film

126 cartridge

Sheet film

35mm cassette

Instant film

Each type of camera takes its own film, which has to be loaded properly

Currently available are a great many films of different sizes which come in a variety of different forms – cartridges, cassettes, rolls and sheets, as well as special film packs for instant picture cameras.

Cartridge films

This type of film is the most recent innovation and appeared on the scene at the same time as the Instamatic cameras designed to use it. There are two sizes of cartridge film – 110 and 126. The former is designed for use with pocket Instamatic cameras and the latter for the larger original Instamatic.

For the snapshotter, these Instamatic cartridges are ideal. The film is attached to a backing paper which is already threaded through the cartridge and all you do is open the back of the camera, drop in the cartridge and close the back again. After winding on to the first frame – indicated by a figure 1 in the window in the back of the camera – you're ready to shoot. Then, when you've finished the film and wound right on, you open the camera again and tip the cartridge out. If you have an automatic Instamatic you don't even have to worry about setting the film speed into the camera; a code notch moulded into the plastic cartridge does that for you.

The smaller 110 film takes pictures roughly 13×17 mm in size – the smallest negatives or slides for mass amateur use – and the larger 126 film takes pictures 28 mm square, although this larger size is now losing favour to its smaller brother. Recent advances in film technology and manufacture mean that enlargements (enprints) up to about $3\frac{1}{2} \times 5$ in (9×10.25 cm) of surprisingly good quality can be produced and it is this, together with the much smaller size of the pocket Instamatic camera, that is leading to the decline in popularity of the 126 Instamatic.

There is not a great range of films available in either of the cartridge sizes, partly because fast films, for instance, wouldn't stand up to the large degree of enlargement necessary to produce even standard enprints, and partly because the snapshotter, for whom these cameras are designed, doesn't need or even want a vast range of different types of film. By far the most popular type of film in cartridges is the colour negative film, enabling the user to drop his used cartridge into the local photofinisher and collect his prints a few days later. The films are available in two lengths – 12 exposures and 20 or 24 exposures.

35 mm cassettes

There can be no doubt that the most popular film size of all with the amateur photographer is 35 mm, and possibly with

the professional, too. For this reason, there's a wider range of different film types available in 35 mm size than in any other size, covering black and white, colour reversal and colour negative, as well as special films such as infra-red, high contrast lith, and so on.

The film is contained in a light-tight metal or plastics cassette fitted with a velvet light trap through which the end of the film protrudes; there's no backing paper as with cartridges and roll films. The protruding end of the film is specially shaped into a narrow tongue to thread into the take-up spool in the camera. Along each edge of the film is a row of holes which engage with a sprocket to transport the film through the camera. When all the exposures have been made the film must be rewound into its cassette before being removed from the camera.

Most 35 mm films are available in 20-exposure and 36-exposure lengths, although some colour negative films are also available in 12-exposure lengths and an alternative 24-exposure length is also becoming popular. The format of each picture is 36×24 mm, but a few so-called half-frame cameras are available which take double the number of shots on a film, each 18×24 mm.

An alternative method of using 35 mm film is to buy it in a bulk length – usually 5, 10 or 30 metres – and load it into cassettes yourself. This has two very big advantages. Firstly it enables you to load a length of film with exactly the number of exposures you want, whether it's 8 or 17 or 26. And secondly, it is very much cheaper than buying film already loading in cassettes – about half the price, in fact. Loading your own cassettes is really quite easy, too, especially if you have a device called a bulk loader which lets you do the whole job in normal room lighting.

The 35 mm format is the smallest practical size for serious photography, and with modern films it is possible to produce really outstanding results from such a small negative. The popularity of this format began in the mid-1920s with the

A medium-speed film can give excellent results outdoors in a 35 mm camera (Len Stirrup)

introduction of the Leica camera which was the first commercially produced still camera to use 35 mm cine film. Since then it has never looked back, offering as it does a large number of shots on each cassette of film. It means you can carry enough film for a busy day's shooting in one pocket. And the camera to use 35 mm film can be made small and light to be carried anywhere, at any time, always ready for use.

In fact, the only time the 35 mm size and format falls down is when you want big enlargements of impeccable quality; in this case there's just no substitute for a larger negative.

Roll film

Roll film used to be available in several widths to suit a great many different cameras, but now it is difficult to find anything but 120 and 620. Roll film cameras provide a convenient compromise between the portability and easy of handling given by the 35 mm camera, and the superior quality given by the 5 × 4 in sheet film camera.

In construction, a roll film consists of a length of film attached at one end (the leading end) to a greater length of backing paper. The whole lot is wound on to a spool which you place in one side of the camera. You then pull the leading edge of the backing paper across the film gate and attach it, through a slot, to a similar spool in the other side of the camera. After each exposure the film is progressively wound from one spool to the other and when finished the fully wound spool is removed from the camera.

Many large format single lens reflexes, such as the Hasselblad and Mamiya RB67, have interchangeable film backs. This means that you can load one back with black and white film and another with colour and you can change from one to the other as many times as you like without wasting or rewinding film.

There are four formats for use with 120 roll film – 6 × 4.5 cm, 6 × 6 cm, 6 × 7 cm, and 6 × 9 cm – of which the first two are the most popular with serious amateur photographers.

Indoors, when a fast film is needed, the extra quality of a 6 × 6cm camera is a great advantage (Len Stirrup)

Cameras taking 6×9cm negatives and slides are largely obsolete now, having been superseded by the 6×7cm format, although there are one or two small sheet film

cameras available which take special roll film backs producing a 6 × 9 cm format. On a 120 roll film you can get sixteen shots size 6 × 4.5 cm, twelve size 6 × 6 cm, ten size 6 × 7 cm, or eight size 6 × 9 cm.

A modified version of 120 roll film is now also available – size 220. This is twice the length of the 120 film and so, obviously, will take twice the number of exposures. However, not all roll film cameras are equipped to accept 220 film, so check the instruction manual with your camera first.

220 roll film is of slightly different construction from 120; instead of having backing paper running the whole length of the film, there is just a short length at the beginning and end – enough to protect the film from fogging when it is not in the camera. This is so that the whole length of film can still be accommodated on a normal 120 size film spool.

Another film variation for certain large format SLRs and other medium format cameras is 70 mm. This is rather like overgrown 35 mm film and is supplied in a cassette or magazine; there is no backing paper on 70 mm film, but sprocket holes are punched in the film. The standard length of film in the cassettes is 15 feet (4.5 metres), which is enough for seventy exposures size 6 × 6 cm or fifty size 6 × 7 cm.

Unlike 35 mm, though, 70 mm film is fed from a cassette in one side of the camera, across the film gate, and into another cassette on the other side. This means that you don't have to rewind the film after use.

Sheet film

Sheet film is for use in medium and large format studio cameras and is available in boxes of between ten and a hundred sheets in sizes from 2¼ × 3¼ in (5.7 × 8.3 cm) to 20 × 24 in (50 × 60 cm), although the most popular size is 5 × 4 in (12.7 × 10 cm), closely followed by 7 × 5 in (18 × 12.7 cm) and 10 × 8 in (25.4 × 20.3 cm).

Each sheet of film is intended to take just one exposure and must be placed inside a light-tight film holder with a removeable slide in front of it before being inserted in the camera.

Most of these holders take two sheets of film, one each side, which reduces the weight and bulk you have to carry. Naturally, this loading of film holders must be carried out in total darkness. To help you do this correctly, every sheet of film has one or a series of notches on one of the short edges. When the notches are in the top right hand corner as you hold the film in front of you, the emulsion side is facing you. The combination of notches also varies according to the particular film, so if you're loading more than one kind at a time you can identify them by touching the notches.

When the film holder is inserted in the camera, the slide in front of the film must be withdrawn ready for the exposure. When the shot has been taken, the slide is replaced and the film holder removed from the camera. Obviously, with all this procedure every time you take a shot, picture taking with a sheet film camera is rather ponderous, but if optimum image quality is what you're after, you'll find it easy enough to put up with the inconvenience.

The range of film types available in sheet sizes is enormous, and apart from the normal materials for general photography there are many highly specialised graphic arts materials. But unless you intend to specialise in architectural photography or some similar branch, you'll probably find that the disadvantages of the sheet film camera outweigh its very real, but limited, advantages.

Instant picture materials

Instant picture cameras and systems are at present available from only two manufacturers – Polaroid, who invented the system, and Kodak – and the two systems are not interchangeable. Basically, the idea of the instant picture material, as its name implies, is to produce a finished picture on the material exposed in the camera, within a few seconds of pressing the shutter release. This is achieved by using special transfer materials and high speed processing chemicals in jelly form which are built into the film.

There is a very wide range of materials available in the Polaroid system, including fast black and white print, a

slower black and white material which produces both a print and re-usable negative, colour print materials, and so on. The range of formats and packages covers eight and ten exposure packs producing print sizes ranging from $2\frac{3}{4} \times 2\frac{7}{8}$ in (7×7.3 cm) to $2\frac{7}{8} \times 3\frac{3}{4}$ in (7.3×9.5 cm. And there are single sheet materials which are designed for use in a special back to fit 5×4 in (12.7×10.1 cm) sheet film cameras and produce a print $4\frac{1}{2} \times 3\frac{1}{2}$ in (10.2×8.9 cm) in size. This particular form of material is used extensively by professional photographers for checking lighting and exposure before shooting colour transparency sheet film. Special Polaroid backs taking packs of film are also available for some large format SLRs, and a comparatively recent innovation is a Polaroid colour system for 10×8 in (25.4×20.3 cm) sheet film cameras which produces superb 10×8 in colour prints direct after processing for only one minute.

The Kodak instant picture system is limited at the moment to just a ten exposure colour print pack with a print format of $2\frac{5}{8} \times 3\frac{9}{16}$ in (6.7×9 cm), which is designed to fit just their own range of cameras.

Instant picture cameras are used a great deal by holidaymakers who want to record places they've visited and want the reassurance that their pictures have 'come out'. But it is possible to do serious work with the system, too, especially if you use the sheet film material with a 5×4 in (12.7×10.1 cm) camera. Ansel Adams, one of the world's greatest landscape photographers, has produced some astoundingly beautiful pictures by this method.

5

Exposure and its control

Correct exposure is the fundamental key to good photography. If you under or over expose the film when you press the shutter release to take your picture, there's little you can do subsequently to compensate for this. So the measurement and application of accurate exposure is of vital importance if you want to produce good results.

Technically, exposure is the product of light intensity and the time for which this light acts on the film. To produce a good negative you must control both of these factors closely, and as explained earlier, this is done with two of the three basic controls on your camera – the aperture and the shutter

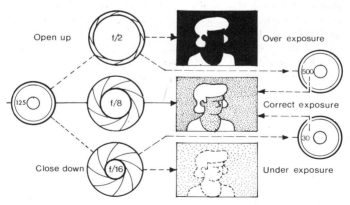

Open up	f/2		Over exposure
125	f/8	500	Correct exposure
Close down	f/16	30	Under exposure

The lens aperture and shutter speed combine to expose the film. Only one exposure level is right for any particular combination of light level and film speed

speed. The aperture controls the intensity of light reaching the film and the shutter speed governs the length of time for which the light acts on the film.

On a simple camera, one or both of these controls may be fixed or have at most only two or three different positions, so the amount of control you have over exposure is very limited, and the only thing you can do is select the appropriate weather symbol to suit the weather conditions. On more advanced cameras both of these controls are variable and there are several combinations of aperture and shutter speed you can use to produce the same negative density. The particular combination you choose will depend on the type of picture.

For example, if you are taking action pictures you will choose a fast shutter speed to stop the action, and a fairly large aperture. But if you are shooting a still life which depends on maximum depth of field you will use a small aperture with a correspondingly slow shutter speed.

The product of shutter speed and lens aperture depends on one other factor – the speed of the film. A film with a slow speed obviously needs light of a particular intensity to act on it for longer than a fast film in order to produce the same result. The exposure necessary to record a subject on the film depends largely on the range of tones in the subject, because it is the subject that determines how much of the light falling on it is reflected back to the camera. So all other things being equal, a subject which consists of dark tones reflects back less light than a light toned subject and therefore needs more exposure.

Brightness range

Just as important as the overall predominant tone of the subject is the brightness range. This is simply the ratio of the

The brightness range of the subject is an important factor in correct exposure. To enable detail to be recorded in both deep shadows and bright highlights in a subject such as this, the exposure must be absolutely accurate. Shot in Cornwall with an Olympus OM-1 (Derek Watkins)

light reflected back from the deepest shadows to that reflected from the brightest highlight. For example, if the highlights of a subject reflect fifty times as much light as the shadows, the subject brightness range is 50 : 1.

Subject brightness range is important to exposure because there are limits to the range of brightness which a film is capable of recording. A black and white negative film will accurately reproduce brightness ranges up to 128 : 1, which is quite high, but even so there are times when you will find subject brightness ranges even higher than this. A typical example is a backlit scene where the brightness range could be as much as 500 : 1. When you come across an instance like this there is not a great deal you can do except decide which tones are more important to your picture, the highlights or the shadows, and modify the exposure so that these tones are accurately reproduced. Shortening the exposure will give correct reproduction to the highlights while the shadows will tend to clog up. On the other hand, lengthening the exposure will open up the shadows to show plenty of detail, but the highlights will become burned out white patches.

Exposure tables and meters

There are several ways of determining the correct exposure for any picture, the most common being some form of photoelectric exposure meter. But more about these in a moment. First let us have a look at a couple of simpler and less expensive methods.

By far the cheapest way of arriving at an acceptable exposure indication is the table in the instruction leaflet supplied in every box of film. Just because this is simple, don't regard it as useless. In fact these tables are really quite accurate as long as the pictures you are taking are fairly straightforward and well lit. It is certainly a lot better than just guessing.

There are other sets of exposure tables available, too. Best and most comprehensive is the set published by the British Standards Institution, upon which most other tables are

based. Its publication number is BS 932:1957. The trouble is, though, that these tables take so much into account that using them becomes a very lengthy and complicated business.

An even simpler method than tables is to use the following rule of thumb. For a front lit subject in full sunlight, use f/16 at the closest shutter speed to the ASA speed of the film you're using. For example, if you're using a film with a speed of 125 ASA, shoot at ⅟125 second at f/16. For a side lit subject

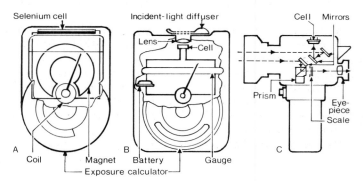

Three types of hand-held exposure meter. A. Selenium cell meters are simple, robust, and need no battery. B. CdS or silicon cell alternatives are much more sensitive. C. A spotmeter allows you to measure the brightness of a very small part of the subject.

use the same shutter speed but an aperture of f/11. And for a back lit subject use the same speed again but this time at an aperture of f/8. Although this simple rule won't take into account the tones in the subject, or any other factors other than the brightness of the light falling on the subject, it should get you reasonably close to the correct exposure. And if it is an important subject you can always take two additional exposures one with the next larger aperture and one with the next smaller aperture as a safeguard.

But now on to meters. There are two types of photoelectric exposure meter, selenium and cadmium sulphide or CdS. The selenium meter consists basically of a barrier layer cell

which converts light into an electrical voltage proportional to the amount of light falling on it, and a moving coil microammeter which measures and indicates this voltage. The CdS meter, on the other hand, uses a photoresistor cell which changes its resistance value in proportion to the amount of light falling on it. A moving coil meter is again used as an indicator, but as the photoresistor cell doesn't generate its own voltage a separate battery is necessary.

Most of the meters on the market, both selenium and CdS, are designed to measure the light reflected from the subject so an important feature of the meter specification is its angle of acceptance which should not be very much greater than the angle of view of a wide angle lens. If it does exceed this angle light from outside the picture area is included and may cause a false reading. A few meters have attachments which enable them to be used as very narrow angle meters. This type of attachment usually takes the form of a small reflex viewfinder and a lens which focuses the chosen part of the subject on the meter cell.

There are a few meters available designed to measure the light falling on the subject rather than that reflected from it and most reflected light meters have an attachment to enable them to be used in this way. Incident light meters, as they're called, have a number of advantages, especially for colour photography, which I'll be dealing with shortly.

Finally there are spot meters which are designed to measure a very small area of the subject. Unfortunately, they're rather expensive and need a great deal of experience to use correctly. But they are capable of extremely accurate results.

Separate meters

Perhaps the majority of amateur photographers these days rely on the through-the-lens meter built into most single lens reflex cameras to give a correct indication of the exposure needed. But there are a great many who still prefer to use a separate meter and there can be little doubt that, used

properly, they can produce more accurate and more consistent results.

The most common method used for exposure determination is the integration method. You simply aim the meter at your subject from a position beside the camera and give the exposure which the meter indicates. When the meter is used in this way it accepts light from all parts of the subject – highlights, shadows and middle tones – and integrates or averages them into a single general reading. This is also the method for which many meters built into cameras are designed.

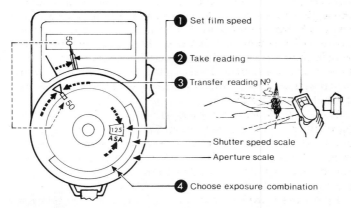

1. Set film speed
2. Take reading
3. Transfer reading Nº
 Shutter speed scale
 Aperture scale
4. Choose exposure combination

Meters have a light measuring system and a simple calculator to convert the measurement to a series of shutter speeds and aperture combinations suited to the film

Generally, the integration method is accurate over a wide range of lighting levels and types of subject, but since the meter indicates a reading based on the light reflected from all parts of the subject, there are certain times when the method falls down. One example is when the subject is a full length figure standing in front of a white wall. In this case the exposure indicated will be affected to a great extent by the large amount of light reflected from the wall. So the whole picture will tend to be underexposed. You can overcome this

81

problem by moving in closer to your subject to take the meter reading so that the wall has less effect on the reading.

You'll get a similar effect if your subject is an open landscape including a large amount of sky. In this case point the meter down slightly or the sky, which is the brightest area in the picture, will have a greater effect on the meter reading than it should and the negative will once again be under exposed.

Since most exposure meters are calibrated by their manufacturers based on a middle grey tone, anything from which you take your meter reading will be reproduced as a middle grey tone in your picture. So there are certain subjects which benefit from an exposure that is modified from that indicated by the meter. Snowscapes, for instance, which are very much higher in overall tone than middle grey, can be given double the exposure indicated by the meter. In other words, open the lens aperture to the next smaller number or change to the next slower shutter speed. On the other hand, very dark subjects – a shot of an old timber barn, perhaps – will be

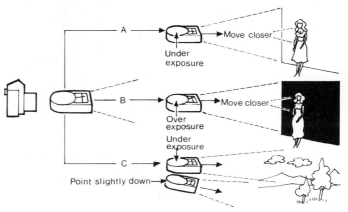

All exposure meters, hand-held or built into the camera, are calibrated to measure from a normal scene. A. With a light background the meter overestimates the light and recommends too little exposure. B. With a dark background, the opposite happens. C. Hand-held meters can be over-influenced by a bright sky; pointed slightly down, they give a more suitable reading

improved by halving the indicated exposure. In other words, close the lens down to the next larger number or move to the next faster shutter speed. Some exposure meters make this modification easier by having extra positions on the calculator dials and you simply set the appropriate one to the reading on the meter instead of the normal main arrow; the indicated exposure is then correct and takes into account the modification factor.

Close-up readings

Many of the problems which arise in the integrated method of exposure measurement can be overcome by simply moving in close to the subject to take your reading.

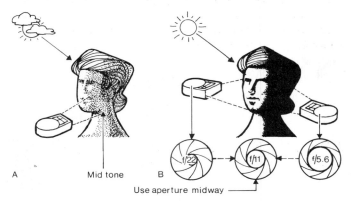

A Mid tone B
Use aperture midway

When the main subject is a small part of the scene, meter from that alone. A. In diffuse lighting, a midtone reading is usually fine. B. With bright lighting it is often better to take shaded and highlight readings, selecting an exposure in between

Take the meter reading from the most important part of the subject that you want to reproduce as a mid grey. In a portrait, for example, this would be the side of the face in light shadow, not the lit side of the face. (This is lighter in tone than mid grey and would need twice the exposure

indicated by the meter.) Readings taken in this way minimise the effect of the background and so the film is exposed for the most important part of the subject. But be particularly careful to hold the meter close enough to the main subject so that no light from other parts of the subject reaches the photoelectric cell. Also avoid casting a shadow on the object with the meter or with your hand. Holding the meter at a slight angle reduces this risk.

Two readings

If your subject is very contrasty, having very deep shadows and very bright highlights, you can often arrive at a more accurate exposure by taking two meter readings. The first of

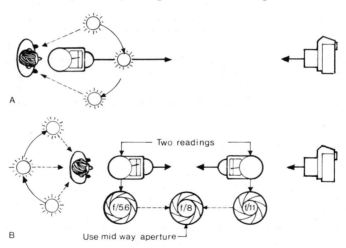

Built-in meters, and most hand meters measure the light reflected from the subject. When the subject is unusually light or dark they can be misleading, and it is better to measure the light falling on it. A. Point an incident-light meter towards the camera from the subject. B. For backlit subjects, the normal incident-light reading may lead to overexposure, so sometimes a midpoint between incident readings gives a better result

these readings should be taken from the brightest highlight in the subject and the second from the deepest shadow. Then, give the exposure which is at a point midway between these two readings. For example, if the highlight reading is $\frac{1}{125}$ second at $f/22$ and the shadow reading is $\frac{1}{125}$ at $f/5.6$, the correct exposure for detail in both highlights and shadows is $\frac{1}{125}$ at $f/11$.

A black and white negative film will record detail over a brightness range of 128 : 1, which represents a difference in exposure meter readings of seven stops. So if the difference between the highlight and shadow readings is more than seven stops some detail in either the highlights or the shadows will be lost.

With colour negative films the brightness range which can be handled without losing detail is only five stops, or 32 : 1, and with colour slide films it can be as little as three stops or 8 : 1. Again some meters have extra markings on their calculator dials which indicate the limits of subject brightness that a black and white film can record, so for any setting of the calculator dial all parts of the subject which fall between these two limits will be correctly exposed. Objects with light values below the low mark will be underexposed and those with light values above the high mark will be overexposed.

Incident light metering

An alternative method of exposure metering which is preferred by some is to base the meter reading on the amount of light falling on the subject rather than on the amount of light reflected from it. A few special meters are available for incident light measurement, but most of the better reflected light meters are supplied complete with an incident light attachment or one is available as an accessory.

The main difference between a reflected light meter and an incident light meter is that the incident meter has an opal light collector over its photoelectric cell instead of a clear receptor lens. The collector is sometimes, but not often, flat; most incident light meters have a dome or inverted cone

collector which accepts light from the front, sides and top, just like the subject itself. The opal light collector is designed to give a correction to the reading so that the meter indicates the correct exposure when set to the normal film speed without the need to make any modifications or calculations to the exposure indicated. Since this correction is constant for any subject or lighting conditions, the brightness of the shadows and middle tones tend to vary from shot to shot while the highlights remain at a constant brightness. For this reason, the incident light method is highly suitable for use with colour slide films as it is desirable to have the highlights in your slides at a more or less similar brightness, so that when the slides are projected on the screen the highlights do not vary in brightness.

Naturally, you must use the incident light meter in a rather different way from a reflected light meter. Because it is used to measure the light falling on a subject, the meter is used at the subject position, pointing towards the camera rather than the other way round. This is very simple if the subject you're taking is a portrait or other fairly close subject, but it could lead to problems if you're shooting a landscape, for example, as the main subject may be anything up to several miles away. However, as long as the light is the same at the camera position as it is at the subject position, you can use your meter to take a reading at the camera position. In other words, it's no use taking an incident light reading at the camera position if the camera is in deep shadow and the subject is in bright sunlight. But remember if you take the reading at the camera position to point the meter towards the camera not towards the subject.

When your subject is lit from the front or slightly from the side, a single incident light meter reading from the subject position towards the camera is sufficient to give accurate results. But when the light moves well to one side or behind the subject a single reading won't give the best result. Instead, you need to take two readings. The first of these is the usual reading with the meter pointing towards the camera and the second is with the meter pointing towards the light source. The correct exposure is then midway

86

between the two readings. So if the first reading indicates $\frac{1}{125}$ at $f/5.6$ and the second indicates $\frac{1}{125}$ at $f/11$, the correct exposure will be $\frac{1}{125}$ at $f/8$.

Corrected incident readings

Because the incident light reading method of metering depends on measuring the light falling on the subject, it cannot make an allowance for the overall tone of the subject. This is why it gives such accurate and consistent results. But there are times when you're shooting a very dark subject – which will reproduce as a realistically very dark slide – and you want to produce a little more detail in the shot. In other words, you need to increase the exposure a little to produce lighter shadows. Similarly, if the subject is very light in tone, and you want to darken it slightly, you'll need to reduce the exposure a little.

In most cases the extent of this increase or decrease in exposure shouldn't be more than half or one stop with colour slide films, but this is rather vague, so there is a more accurate way in which you can find out exactly how much to modify the indicated exposure.

When you take a reflected light reading from a subject which is predominantly dark, you need to decrease the exposure from the indicated value to prevent overexposure. In other words, the reflected light meter indicates an exposure which will give too light a tone. Now with the incident light meter we want to increase the exposure indicated to lighten the tone of the subject, so it becomes logical to take an incident light reading in the normal way to establish the level of light falling on the subject, then a reflected light reading to determine the amount by which the subject is darker than average. The correct exposure is midway between these two readings.

Here's an example. The subject has a large dark but important area on one side while the other side has a small but equally important area which is light in tone and brightly lit. First take an incident light reading in the usual way; the

indicated exposure is $\frac{1}{125}$ at $f/11$. Now take a reflected light reading. Because the subject is predominantly dark the reflected light reading will indicate more exposure – $\frac{1}{125}$ at between $f/5.6$ and $f/8$, perhaps. If you give an exposure midway between these two – $\frac{1}{125}$ at a fraction over $f/8$ – the dark area will show more detail than if you had exposed for just the incident light reading, but the light area won't burn out as it might have done if you had exposed for just the reflected light reading. What this method does, in fact, is produce the best possible compromise for a very contrasty subject.

This mixed reading method works well at the other extreme, too. If the subject is predominantly light and you want more detail in the high values, the incident light reading will be lower than the reflected light reading, so when you take a position midway between the two you get a slightly reduced exposure which again represents the best possible compromise.

It works well, too, when shooting subjects against the light on colour slide film. It prevents detail in the shadows becoming totally lost on the one hand and glaring empty highlights on the other.

Through-the-lens metering

Cameras with built-in exposure meters have been available for a long time. In early models, as well as in some cameras still available today, the built-in meter consists of the mechanics of a separate hand-held meter but contained within the bodywork of the camera. In use they behave exactly like separate hand-held meters and must be used in broadly the same way. This type of meter is fine for fixed lens cameras because the acceptance angle of the meter can be designed to correspond with the angle of view of the camera lens. The problem comes with interchangeable lenses, because the acceptance angle cannot be changed to suit lenses of different focal lengths. This was a major disadvantage with built-in meters for a long time, but since the early 1960s

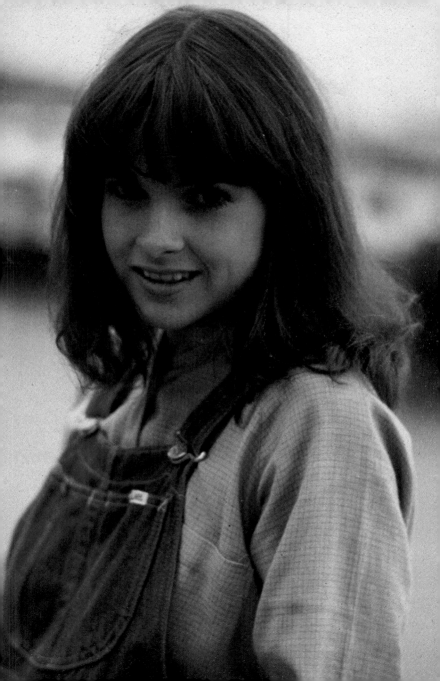

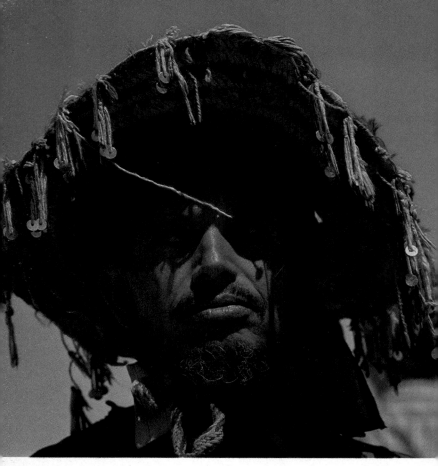

Previous page: A 35 mm camera with its choice of lenses is excellent for outdoor portraits. Choose a lightly overcast day for the most flattering results (Michael Taylor)

Above: Strong sunlight and a 6 × 6 cm camera reproduce every detail in the tribesman's face. Beware of underexposing the shadows (Michael Barrington-Martin)

Opposite: For carefully composed studio work, a cut-film 'view' camera is ideal. The effect of the modelling lights is seen easily on the viewing screen (Michael Barrington-Martin)

Above: A 35 mm SLR with moderately long focal length lens allows an out-of-focus foreground to be carefully composed (Brian Angus)

Opposite: For close-ups, a 35 mm SLR with extension tubes is ideal. *Top:* Bright sunlight makes a colourful picture (Derek Watkins). *Bottom:* Flash freezes and isolates a nearby hibiscus bloom (B. Gibbs)

The square format of a 6 × 6cm camera is ideal for peaceful landscapes (Derek Watkins)

Opposite: A 6 × 4.5cm transparency provides excellent image quality, and enlarges to fill most common paper sizes (Ron Tenchio)

Next page: A 6 × 6cm camera offers the same image area when the page is filled. A high quality lens is essential for direct into-the-sun pictures (Michael Barrington-Martin)

single lens reflex cameras have been available with a built-in meter that measures the light actually entering the camera through the lens. Today, virtually every SLR is fitted with through-the-lens metering, or there is a metering prism available to convert it to TTL metering.

Most TTL systems take a meter reading from the whole of the subject as seen by the camera lens. This means that, no matter what focal length of lens you are using, the meter considers only those objects and brightnesses within the field of view of the lens. So potentially you have a better chance of achieving correctly exposed pictures with TTL metering than with a separate meter. But there can be problems as we'll see in a moment.

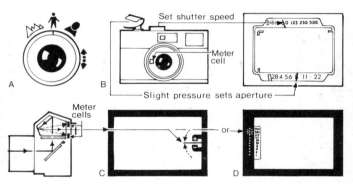

Simple compact cameras have focus symbols (A) and often automatic exposure control. Many select the lens aperture automatically to suit the preset shutter speed (B). SLRs offer screen focusing and through-lens exposure control. Manual exposure models have a needle or LED display to show when the controls are set to the metered exposure (C). Auto-exposure models usually display the shutter speed to suit the chosen lens aperture by an LED or needle in the viewfinder (D)

A major advantage of TTL metering is that you can keep an eye on changing light conditions and make any adjustments necessary right up to the moment of pressing the shutter release. The exposure information is displayed in the viewfinder by means of a needle or tiny lights, so you don't have

to take your eye away from the viewfinder. This easy reading feature of TTL metering also means that this type of meter is faster to use than a separate meter. And, of course, you don't have the inconvenience of having to carry a separate instrument around with you. On the other hand, if something goes wrong with your meter you lose your camera as well while the trouble is sorted out.

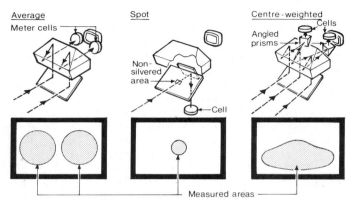

SLR meters vary in their sensitivity to various parts of the scene. Most now, though, have centre-weighted meters which give the highest proportion of accurate readings

In addition to varying the angle of acceptance to suit the lens being used, the TTL meter also takes account automatically of any accessories fitted to the lens – filters, polarisers, extension tubes or bellows, and so on. The danger with filters, though, is that some types of photoelectric cell are more sensitive to some colours than to others. Cadmium sulphide, for example, is very sensitive to red, so if you give the exposure set by the TTL meter when using a red filter you may find that your picture is underexposed. So the safest way is to take a reading without the filter then apply the filter factor, screwing the filter on just before taking the shot.

With extension tubes and bellows you often have to increase the exposure indicated by a separate meter quite

dramatically to allow for the greater distance between the lens and the film. With a long extension and a wide angle lens this can be as much as five stops or even more, but with TTL metering this increase is taken care of automatically, which can be a real help.

TTL metering methods

In general, there are three systems of TTL light measurement in current use. The first, which was used extensively in early cameras, but is now rather out of favour, is the average system. This measures light from all parts of the subject and integrates or averages it to give the reading. While the averaging system can give accurate results if the subject is evenly lit and has a fairly uniform distribution of light and dark tones, it can give a misleading reading with other types of subject. However, you can counteract this to a degree by taking your reading close up to the subject.

The second method, used in comparatively few cameras, is the spot system. Although it can be by far the most accurate system, it requires a lot more care in use and more experience to interpret the reading. The reason is that the metering area is designed to produce a middle grey tone, so you must choose a suitable area of the subject from which to take your reading. And if you take a reading from a very light or very dark area it will have to be modified to take into account the difference in tone between the measured area and a middle grey. This modification may be as much as three stops either way to give the best results.

Finally, there's the system most commonly used – the centre weighted system. In some ways this is rather like a combination of the other two systems. The meter takes into account the whole area seen by the lens, but takes more notice, as it were, of the central area or of the central and lower area. This means that, in landscapes, for instance, the main part of the metering is done on the foreground and middle distance but the sky contributes little to the indicated exposure. This makes a lot of sense, since the sky is usually

the brightest area of the picture and can easily give an inflated reading which leads to underexposure. The problem comes when you want to take a vertical picture, and turn your camera on its side. The meter then takes more notice of one side of the picture than the other and may give quite the wrong result. Fortunately, there is a simple way round it. Take your exposure reading with the camera held horizontally then turn it vertically to take the picture.

Typical centre weighting produces about 60% of the reading from the central and lower area of the picture and the remaining 40% from the rest of the frame.

TTL problems

On the face of it TTL metering seems to be the universal answer to all exposure problems, and in a lot of cases it does give very accurate results. For straightforward landscapes and other shots lit from the front or slightly to one side and with a uniform distribution of light and shade the TTL meter will give the correct exposure. But as the light moves progressively more to the side or as the subject becomes predominantly light or dark in tone, less than satisfactory results will be obtained by following blindly what the meter says. Take, for example, a street scene with a whitewashed building occupying a large part of the foreground. If you take a straight TTL reading you will almost certainly get an underexposed negative or slide if you give the exposure indicated. The reason is that the whitewashed building reflects a large amount of light and this has a disproportionate effect on the meter reading causing it to indicate a shorter exposure than is really needed for the rest of the subject. So the shadows tend to clog up.

The opposite is true if the subject has a large area occupied by a dark object. The negative or slide will in this case be overexposed with the result that any highlights will be burned out.

In cases like these you have to apply a correction factor to the meter reading to allow for the disproportionate effect of the large light or dark area. This will usually be about one

stop more exposure for predominantly light subjects and one stop less for predominantly dark subjects. Alternatively, you can move in close to the main subject to take your reading then move back to your chosen viewpoint to take the shot. This way you'll eliminate the effect of the large light or dark area. Another way to do this if you can't get closer to the main subject is to change to a longer focal length lens to take the reading. This will make the subject larger in the viewfinder and will again eliminate the effect of the light or dark area. But don't forget to change back to the lens you want before you take the picture.

Full aperture or stopped down?

Early cameras with TTL metering were used in the stopped down mode. That is to say, as you varied the aperture to get the meter needle to the reference point in the viewfinder,

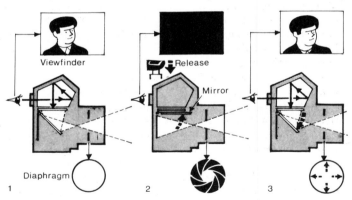

Operation sequence of an SLR camera

the lens aperture actually closed or opened giving a change in brightness of the viewfinder image. Modern SLRs, though, tend to make use of the full aperture system. In this system the lens aperture control is linked mechanically or electrically to the metering equipment and while turning the aperture

ring changes the meter reading it doesn't open or close the lens aperture. This means that the image in the viewfinder remains at full brightness during the metering procedure, but the lens closes to the chosen aperture when you press the shutter release.

Both systems have their advantages; the stopped down system is potentially the more accurate since it meters the actual light transmission of the lens at various apertures which can differ from the theoretical values given by the mechanical or electrical linkages. But at low light levels it can be very difficult to see the meter indication when the lens is stopped down.

The full aperture system is more convenient, especially at low light levels, and modern design and production have made this system much more accurate than early full aperture systems, at least, on better SLRs, but if you want to stop down to see the depth of field you have to operate a separate button. The system is also more complex and therefore more likely to go wrong.

Automatic exposure control

Once camera designers had perfected through-the-lens exposure metering for SLR cameras it was but a small step to making the meter actually set the aperture at which the exposure should be made. This was the first type of automatic camera and the system worked with a servo-mechanism. However, the space age was beginning to produce spin-off advantages and brought advanced technology to the camera industry. With computer circuitry now reduced to the silicon chip, or microprocessor to give its proper title, it has become possible to build small computer functions

Automatic cameras can give incorrect results if the subject is predominantly light or dark in tone,. This building was white and has been grossly under exposed (*top*) because it reflects a large amount of light. To correct it (*bottom*), the lens aperture had to be opened by two stops (Derek Watkins)

inside cameras. It is this possibility which has enabled automatic cameras to become so advanced so quickly.

So now functions such as shutter speeds and self-timers are controlled electronically instead of mechanically, and central processing units take information from light measuring cells and control the electronic shutter timing circuits, making the whole thing completely automatic.

Types of control

There are two quite different forms of automatic exposure control systems which both end up doing the same thing. First, there is the aperture preferred system and secondly there is the shutter preferred system. The difference between these two systems is simple. With the first you set the lens aperture to the f/number you want to use and the camera takes care of the shutter speed, choosing the right speed to give a perfectly exposed slide or negative. The shutter speed the electronics choose is usually displayed in the viewfinder just to keep you informed. Sometimes the

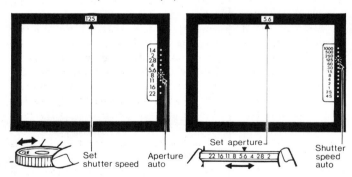

Automatic exposure systems in SLR cameras, and in some viewfinder models, may give priority to aperture or to shutter speed; some offer the choice. Shutter priority cameras automatically set the lens aperture to match a preset speed. Aperture priority models adjust the shutter speed to suit a preset diaphragm setting. Most display the setting on an LED array in the viewfinder

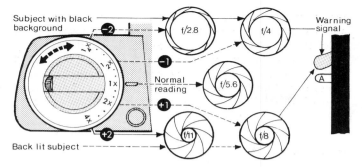

Subject with black background

−2

−1

Normal reading

+1

+2

Back lit subject

f/2.8

f/4

f/5.6

f/11

f/8

Warning signal

A

1x

2x

4x

To cater for unusual subjects or lighting most automatic-exposure SLR cameras have an exposure compensation dial. Set it to give less exposure with dark subjects or subjects against a dark ground; to give more for light or backlit subjects. A few cameras have a viewfinder warning when compensation is in use

lens aperture you choose is displayed, too. On simpler cameras, instead of displaying the shutter speed, a warning light glows if the speed is slow enough to need a tripod in order to eliminate the chance of camera shake or if the exposure necessary is longer than the longest time the electronics are capable of giving.

With the shutter preferred system you set the shutter speed to the value you want to use and the camera selects the correct aperture for perfect exposure. The aperture set by the camera is usually displayed in the viewfinder along with the shutter speed selected. But again, with simple cameras, there may be just a warning lamp which glows to tell you that you must change to the next shutter speed so that the lens can cope with the light level.

Both systems have certain advantages and the one you choose depends largely on the kind of photography you do. If you're interested in sports photography where the choice of shutter speed is important to enable you to stop action, then you would choose a shutter preferred system. But if you do a lot of close-up work where you need to control the depth of field, the aperture preferred system is probably best for you. In fact, for normal everyday photography covering a

lot of different types of subject, you will find that the aperture preferred system is generally the most suitable.

There are cameras that will do both. The Canon A1 has no less than five different automatic exposure functions – shutter preferred, aperture preferred, programmed (a combination of the first two), stopped down automatic, electronic flash automatic, plus fully manual for good measure.

Using an automatic

Although achieving the correct exposure with an automatic camera would appear to be perfectly straightforward, there can be problems. An automatic camera, no matter how advanced, can only do as it is told; it cannot think for itself. The problem is that because the camera is controlling things you tend to get left out, so if the subject you're shooting is anything but an average scene, lit from the front or slightly to one side, the results you will get are not as good as they could be.

As pointed out earlier, if the subject is a smallish dark area against a very light background, the metering system will be over-influenced by the light area and will give less exposure than is necessary for the correct recording of the main subject. The opposite applies in the case of a small light toned subject against a large dark background. But with an automatic, the camera is in charge and since it is programmed to assume average subjects, it will automatically give the wrong exposure, and there would seem to be little you can do about it. But there are ways around the problem.

Bucking the system

On the more advanced automatics there is usually a small control which lets you compensate for out-of-the-ordinary subjects or lighting conditions. It consists of a dial, often incorporated in the film speed setting dial, which is calibrated either ¼, ½, 1, 2, 4 or -2, -1, 0, $+1$, $+2$, usually with

intermediate marks as well. When this control is used the exposure given is modified from that which the automatic system wants to give.

For example, if the control is set to ¼ or −2 the exposure given is two stops less than the automatic system indicates. Or if it is set at 2 or +1 it gives one stop more than the system says. Use the ½ and ¼ settings (or −1 and −2) when the subject is predominantly dark to avoid overexposure and the 2 and 4 (+1 and +2) positions when the subject is predominantly light.

Simple automatics don't have this control but there is still a way round the problem. If the subject is predominantly light set the film speed on the camera to half or a quarter of its normal value to increase the exposure given. And if it is predominantly dark, set the film speed to twice or four times its normal value to give less exposure. But don't forget to return the control to its normal value before you take the next shot.

Automatic or manual?

Cameras with automatic exposure control have a lot of advantages for normal everyday photography. By taking care of the technical side of picture taking they enable you to concentrate fully on the composition of the shot and the viewpoint. If you can do this without having to worry about getting the exposure right your pictures are almost certain to start improving.

But if you like to stay fully in control of things then a manual camera is probably a better choice for you – possibly one without any form of built-in exposure metering at all, enabling you to use a separate meter to produce exactly the kind of results you want. Also, a non-automatic camera tends to be less expensive than a fully automatic one.

Perhaps the best choice of all is a camera which is fully automatic but has a manual over-ride so that if you feel that you do want to have full control over exposure you can switch from one mode to the other quickly and easily.

Camera types

In the first chapter we looked briefly at the types of camera which are suitable for different types of photography, but now is the time to look at these different cameras in a little more detail: at their features, their advantages and their disadvantages.

Many features are common to all cameras – lens, viewfinder, shutter, aperture and so on – and these have been dealt with already. So has the way that film controls, to a degree, the physical size of the camera; no matter how compact a camera is designed, it cannot be made smaller than the film format.

Instamatic cameras

The main advantage of Instamatic cameras – both 126 and 110 pocket models – is their extreme simplicity in use. As we've seen, to load the camera you simply open the back, drop in a new cartridge of film, and close the back again. The film wind is interlocked with the shutter release to prevent double exposures and blank frames, and the shutter or aperture control is usually labelled with simple weather symbols. Added to this, the lens has a short focal length and a fairly small maximum aperture, so a focusing control is unneccesary because everything from about 6 feet (2 metres) will be acceptably sharp.

So the Instamatic really does come into the 'point and shoot' category of cameras, and for many amateurs this can be a real benefit. For as long as you accept the inevitable

limitations of such a camera and work within those limitations, there is no reason at all why your pictures should not be just as good as those taken on far more complex and expensive instruments. In fact until the user of a complex camera learns to master the controls, the results could well be less successful than those from an Instamatic. The simple Instamatic, then, frees you to concentrate on what, after all, is the main purpose of photography – the picture itself. Because you don't have to worry about setting controls, you can spend the whole of your effort framing the subject in the way you want it.

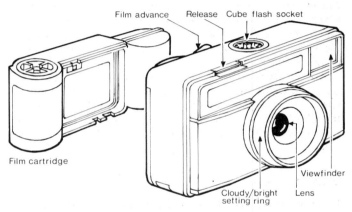

Film advance Release Cube flash socket

Film cartridge

Viewfinder

Cloudy/bright Lens
setting ring

A simple 126 'Instamatic' camera, ideal for holiday shots

Why buy a more complex and expensive camera, then? A good question. The only things an advanced camera will give you are increased versatility and *technically* better pictures. By technically better is meant sharper, because the better quality lens will produce a crisper, sharper image on the film, and because you have full control over the focusing of the lens you can choose exactly what will be sharp in the picture. Also, because the shutter speed and aperture are adjustable you will get more precisely exposed pictures.

But to get back to the Instamatic. The very simple models usually have a lens with a fixed aperture of about *f*/8 and a

101

shutter speed of about $\frac{1}{60}$ or $\frac{1}{125}$ second, depending on the lens aperture. Those with a two speed shutter have $\frac{1}{125}$ or $\frac{1}{250}$ second as a fast speed and $\frac{1}{30}$ or $\frac{1}{60}$ second as a slow speed, which is also used when taking flash pictures indoors. These speeds are normally selected by a small sliding lever and have a sun symbol for the fast speed and a cloud for the slow one; the slow speed is often selected automatically when you attach the flash unit for indoor shots. A very few of these simple Instamatics have a photocell built in which lights a warning lamp when there is insufficient light to take an acceptable picture.

For those who want a bit more versatility than these very simple Instamatics can give, there are several adjustable Instamatics now available, mostly in the 110 size. These vary from a couple of extra shutter speeds or apertures and zone focusing, to interchangeable lens, fully adjustable single lens reflexes taking 110 film cartridges, and include several models with fully automatic exposure control which ensure properly exposed negatives or slides in virtually any lighting conditions.

The main problem with these more advanced Pocket Instamatic cameras is that one of the major advantages of this very small format is lost. With the increasing complexity the physical size of the camera increases to the point where it is very little smaller than, say, a compact 35 mm camera. Indeed, some are very nearly as big as the modern compact 35 mm SLR.

Personally, I can't see a great deal of justification for producing a 110 size SLR with interchangeable lenses or a zoom lens. The cost of such cameras is at least as high as a 35 mm SLR, yet the results they will produce can never approach those produced by the larger format – the negative is simply too small. And I can see no point at all in spending that kind of money and not being able to have acceptable prints bigger than a postcard. As just pointed out, too, the physical size of the camera is no real advantage; you merely have a normal size camera producing a tiny negative.

The fully automatic 110s, though, are a different case. They stick to the basic Instamatic concept of extreme simplicity

and a small physical size, but with better exposure control. With this type of camera you don't even have to remember to set the little lever to the right weather symbol. You can just shoot away and as long as the warning light in the viewfinder doesn't glow you can be sure of a properly exposed picture.

The cartridge of film tells the automatic exposure system in the camera what speed it is when you drop it into the camera. A small notch in the cartridge links with a lever attached to the metering system to do this job, so you don't have to remember to set anything yourself.

Some of these automatic 110s have a rudimentary focusing system. Like the exposure control on the simpler cameras, it relies on symbols – a head, a half-length body, a group, or a mountain. You simply select the one most appropriate to the picture you're taking and depth of field takes care of the rest.

Case becomes handle

Telephoto

110-size cameras are usually pocketable. The simplest are just like 126 cameras, good for snapshots. More sophisticated models offer built-in telephoto lenses, electronic flash and so on

One or two Pocket Instamatics are now fitted with a simple optical device which changes the focal length of the lens to give a telephoto effect similar to that given by a short telephoto – 85 or 90 mm – on a 35 mm camera. This device doesn't increase the size or the cost of the camera very much and is therefore quite a useful feature to have, especially if you take a lot of pictures of people.

Virtually all Instamatics have some provision to enable you to take flash pictures indoors. At the less expensive end of the scale this takes the form of a socket on top of the camera into which you plug a Magicube – a device in the shape of a cube with a tiny flashbulb and reflector on each of its four vertical faces. As you take each picture, the cube automatically turns to present the next bulb until all four have been used. Some Instamatics have a warning light in the viewfinder which tells you when you've reached this point. Other 110s have a built-in electronic flash unit which has the advantage that you don't have to keep buying expensive Magicubes; the electronic unit has a tube that isn't likely to expire during the life of the camera, so all you need to replace once in a while is the battery. On some cameras the flash unit is permanently built in, on others it fits on to one end of the camera. The more advanced 110s with interchangeable or zoom lenses have a 'hot shoe' which accepts a normal electronic flashgun as used by larger cameras.

Compact miniatures

If you want to stick with a simple, easy to use camera but would like a better quality picture, you will not do better than buying a compact 35 mm camera. This type of camera produces a negative or slide four times the size of that produced by a 110 camera and the lens is invariably of better quality as well. This means that your postcard-sized prints will be far sharper and clearer than those from a 110, and you can, if you like, have enlargements up to about 12×10 in $(30 \times 25$ cm) made before the quality even starts to deteriorate.

What do you pay for this extra quality? Very little, in fact. Many compact 35 mm cameras cost little more than a good 110, many are not much bigger – especially the Rollei range with collapsible lenses which retract into the body when not in use – and are just as pocketable as a 110. But you do lose the extreme simplicity of loading and unloading. Once you've practised loading a 35 mm camera a few times, though, you'll find it isn't at all difficult.

All the compact 35s are fitted with a fixed or non-interchangeable lens which is usually slightly wide angle – about 35 to 45 mm in focal length – and with a fairly wide maximum aperture of f/3.5 or even f/2.8. There is usually some form of focusing scale – either a set of symbols or a distance scale in feet, metres or both. The first you use by

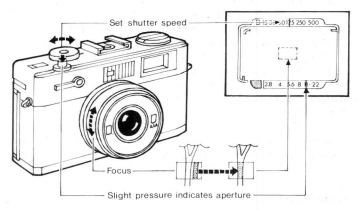

Set shutter speed

Focus

Slight pressure indicates aperture

Compact 35 mm cameras are probably the best fixed-lens cameras for travel and holiday pictures. Most have automatic exposure control, and can be used in all normal lighting conditions. The better models incorporate a rangefinder to indicate sharp focus

selecting the appropriate symbol for the picture you want to take, and with the second type you estimate the distance of your subject and set this on the focusing scale. In most cases the focusing extends from about 3 feet (1 metre) to infinity, but you can often buy a close-up lens to enable you to get even closer to your subject. In this case, though, you will have to measure the distance carefully with a tape measure or your pictures may be unsharp.

Exposure with compact 35s is governed by the usual combination of shutter speed and aperture controls, and many of these cameras feature fully automatic exposure control. These give a shutter speed that may vary anywhere between ten seconds and $\frac{1}{1000}$ second and an indication is

often given in the viewfinder to tell you what speed is being used. Alternatively, a warning light may glow when the automatically selected shutter speed is so slow that you may get camera shake. In this case you should fix your camera to a tripod or place it on a table or something similar to prevent movement during the exposure.

Non-automatic cameras in this class have manually set shutters with speeds ranging from about 1/500 second at the fast end to 1/30 second at the slow. This is the slowest practical speed at which most people can hold a camera steady enough not to get camera shake. Some cameras extend to slower speeds, but all have a B setting so that you can give an exposure of several seconds when the camera is fixed on a tripod. Most non-automatic compact 35s feature a built-in exposure meter on top of the camera, though obviously not a TTL type.

A few of the more expensive compact 35s have a coupled rangefinder to help you focus accurately. Although it does ensure sharp pictures every time, it really comes into its own when you're shooting in dim light. This calls for a relatively large aperture to ensure adequate exposure and, as explained earlier, a large aperture means less depth of field, so you need to be more accurate with your focusing. The coupled rangefinder is also extremely useful when you take pictures at fairly short distances. Again, depth of field is reduced and a focusing aid helps to produce sharp pictures.

As mentioned at the beginning of this section, the biggest advantage a compact 35 gives you over an Instamatic – especially the 110 Pocket Instamatic – is improved picture quality and much clearer enlargements, but there are other advantages, too. There is a much wider selection of films available in 35 mm than in other sizes, for instance. And if you take colour slides, your pictures will fit any standard slide projector. But perhaps most important of all, the compact 35

Compact miniatures are ideal take-anywhere cameras, small enough to carry in your pocket but with the advantage of a much larger negative than you get with a pocket Instamatic. Wenlock Priory, Shropshire taken on a Rollei B35 (Derek Watkins)

provides a much better jumping off point, as it were, into more serious photography. If you get bitten by the photographic bug, you will become dissatisfied with an Instamatic very quickly, but a compact 35 will continue to be a valuable part of your equipment for a long time. In fact I regularly use my own compact 35 – a Rollei B35 – when I don't want to take

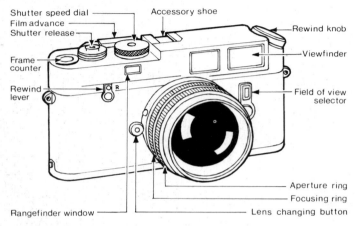

Shutter speed dial
Film advance
Shutter release
Accessory shoe
Rewind knob
Frame counter
Viewfinder
Rewind lever
R
Field of view selector
Aperture ring
Focusing ring
Rangefinder window
Lens changing button

The Leica M4-P is the latest in a line of precision 35 mm rangefinder cameras. It offers a range of excellent lenses and accessories to the photographer who values rangefinder focusing

my SLR or TLR gear around with me. The little B35 lives permanently in my briefcase and so is always with me to capture those surprise shots that come along from time to time.

Much of what I've written about compact 35s applies equally to what used to be the most popular type of camera in the 1960s – the rollfilm folding camera. Although these are no longer produced (apart from a single Chinese model) they do appear from time to time on the secondhand market,

A compact 35 mm camera is ideal for most outdoor activity, providing an excellent combination of performance and simplicity while being highly portable (John Woodhouse)

usually at very reasonable prices. Please don't despise these simple, seemingly old-fashioned cameras. While they lack many of the refinements we've come to treat as standard on modern cameras – like interlocked shutter and film wind – they are, nevertheless, capable of producing really excellent results.

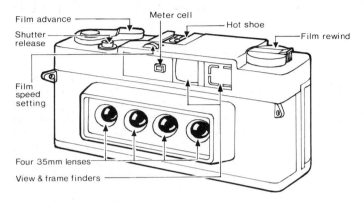

For many years, manufacturers have offered stereoscopic cameras of one sort or another. The Nimslo system uses four lenses to take four simultaneous images on 35 mm film. Computer-controlled printers then transform the four images into a single lenticular print which appears three dimensional

The most popular negative size with folding cameras was 6 × 6 cm, although there were a great many with the larger 6 × 9 cm format produced. But either way, you start with a much bigger negative than with a 110 camera – about twenty times bigger in the case of 6 × 6 cm, in fact – and nearly four times the size of a 35 mm negative. This means that you can produce really big enlargements without losing quality, and because the lenses used in these cameras are similar in design to those used in the compact 35, your prints and slides should be very sharp and clear.

If you decide to buy a secondhand folding camera, the main thing to look for is that the bellows are in good condition. Open the back of the camera and place your eye

in the film gate. Now hold the camera near a very bright light and move it about, looking for tell-tale pin-pricks of light. If you see any, the bellows have tiny holes in them which need attention before you buy the camera.

Like the Pocket Instamatic and most compact 35s, the roll film folding camera is a truly pocketable instrument. When closed, it is barely an inch (about 2.5 cm) thick and measures about 3 by 5 in (7.5 × 13 cm).

Rangefinder 35 mm interchangeable lens cameras

This group of cameras is about the smallest in terms of numbers of models available. In fact it is probably true to say that the only camera in this group currently being produced is the Leica – the original 35 mm still camera. Until the 35 mm SLR came on the scene, the 35 mm coupled rangefinder camera was one of the two types of camera which most serious amateur photographers aspired to (the other was the 6 × 6 cm twin lens reflex). And for this reason it remains one of the classics of all time.

Personally, I've never taken to the 35 mm CRF; I find it difficult to focus quickly and the range of lenses that will couple with the rangefinder is very limited. Nor will the standard lens focus to closer than 3 feet (1 metre) whereas most SLRs will halve this distance. And there is the problem of parallax error because the viewfinder sees the subject from a slightly different position than the lens. But I must stress that this is purely a personal opinion; I know several photographers who use Leicas and wouldn't change them for anything. It's a question of paying your money and taking your choice.

The big advantages that a 35 mm CRF camera offer are light weight, small size and reliability. All these are the results of the relatively simple design of this type of camera.

Today, users of this type of camera tend to be devoted amateur or professional photographers, and the features built into the camera reflect this. There are none of the gadgets – mostly of doubtful use anyway – that seem to have become the norm on SLRs, presumably to appeal to the mass

market. Only one has TTL metering and none of the others has even a built-in exposure meter. What you do get for your money (a lot of money) is a very basic but superbly precision engineered camera capable of producing the highest quality results.

The standard lens fitted to a 35 mm CRF camera usually has an aperture of about $f/1.8$ to $f/2.8$ and the range of shutter speeds extends at least from one second to $1/1000$ second, giving you everything you need for good photography.

Despite my own misgivings, most people find the CRF camera very quick and easy to focus, and the subject easy to frame in the viewfinder. The problems start when you change from the standard lens. Although the viewfinder incorporates frames for three or four lenses – typically from 35 mm to 135 mm focal length – to indicate the appropriate field of view, the viewfinder image stays the same size while the frame size changes, which I find rather disconcerting. But when you use a shorter focal length lens than 35 mm or a longer one than 135 mm, you have to use a separate viewfinder as well. This means that you have to look through one finder to focus then switch your eye to the other finder to frame the picture, which is a bit awkward to say the least. And not many lenses outside the 35 mm to 135 mm focal length range will couple with the rangefinder system, so you have to use some other means of distance measurement. Leica recommend their Visoflex reflex housing when using lenses longer than 135 mm focal length. This device converts the Leica into a rather rudimentary (and very expensive) single lens reflex.

However, used with the limited range of coupling lenses, the CRF 35 mm camera is a superb instrument, so if your photography is unlikely to extend to lenses outside this range, and if you have a very deep pocket, you could do a lot worse than buy a Leica.

Single lens reflex

The single lens reflex, or SLR as it is popularly known, is perhaps the closest approach to the universal camera. No

112

other type of camera is suitable for so many different applications, and while in some cases another type of camera may do a *particular* job better, it almost certainly won't be able to handle a *range* of jobs so well.

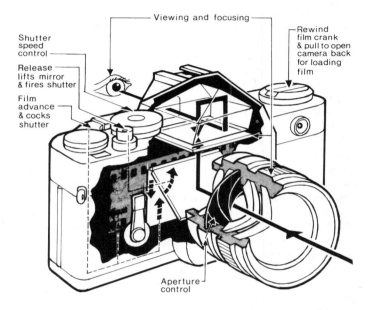

A typical 35 mm SLR offers through-lens viewing, focusing and metering with an enormous range of lenses and accessories, making it the first choice of the enthusiast and the photojournalist

A life-size, right-way up, right-way round viewing system is the biggest single advantage which the single lens reflex with a pentaprism viewfinder has over other types of camera. Of equal importance, though, is the fact that when you look into the viewfinder you see the subject from exactly the same position that the lens sees it, because the viewfinder image is produced by the camera lens. Other types of camera have viewfinders which are separated from the lens by a few

113

centimetres and at close range the resulting difference in viewpoint can make a significant difference to the picture.

With the SLR you always see exactly what you will get on the negative or slide, no matter which lens you use or whether you are using close-up attachments. In addition to composing your pictures accurately, you can also focus them accurately and easily.

Next most important, the SLR allows you to use an incredibly wide range of different lenses to produce different images, as explained in Chapter 3. All kinds of attachments can be fitted to your SLR – close-up lenses, extension tubes, bellows for extreme close-ups, filters, diffusers, microscopes, telescopes and so on. No matter which of these you use, you always see exactly what you're shooting.

However, it would be foolish to think that the SLR does not have any disadvantages – it does. But they're relatively small and insignificant when set against the advantages. For instance, many photographers dislike the disappearance of the viewfinder image at the instant of exposure. It doesn't bother me, but I take the point. SLRs are generally bigger and heavier than rangefinder 35mm cameras, but with the current trends pioneered by Olympus this is becoming less of a problem.

The combination of a focal plane shutter and a swinging mirror tends to make the operation of an SLR rather noisy and can cause camera movement. The focal plane shutter will not synchronise with electronic flash at speeds shorter than $\frac{1}{60}$ or $\frac{1}{125}$ second, but the only time this could be a real problem is when you're using fill-in flash in bright sunlit conditions. Other types of camera with a focal plane shutter also have the same problem.

SLRs have far more moving parts than other types of camera, and with the increasing use of electronics they are becoming more and more complex. So when anything goes wrong the repair bill tends to be high. Fortunately, though, camera construction is fairly sturdy and the design reliable,

The focusing screen of a 35mm SLR provides exact composition and focus (Valerie Bissland)

so if you handle your camera with reasonable care it should not need repairing too often.

In addition to the main focus, shutter speed and aperture controls, the SLR has several other controls which other cameras lack.

First there is the preview button. Most lenses for SLRs are now fully automatic in that they allow you to focus and make exposure readings at maximum aperture and only stop down to the working aperture when you press the shutter release. This means that you cannot actually see the depth of field. But again most lenses are now fitted with a depth of field preview button which closes down the lens to the selected taking aperture. When you press this button the focusing screen becomes darker because of the reduced amount of light passing into the camera, but it enables you to check visually how much of the subject is sharp.

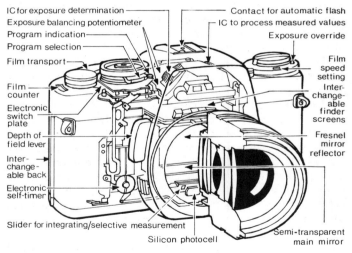

IC for exposure determination — Contact for automatic flash
Exposure balancing potentiometer — IC to process measured values
Program indication — Exposure override
Program selection
Film transport — Film speed setting
Film counter — Inter-changeable finder screens
Electronic switch plate
Depth of field lever — Fresnel mirror reflector
Inter-changeable back
Electronic self-timer
Slider for integrating/selective measurement
Silicon photocell — Semi-transparent main mirror

Top quality 35mm SLRs incorporate a host of electronic and mechanical features to give a choice of automatic exposure programmes and a viewfinder information centre which displays just about every camera setting available. Such cameras are designed for use with an enormous 'system' of accessories and lenses

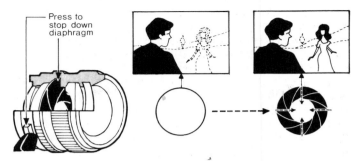

Press to
stop down
diaphragm

The smaller the aperture the greater the depth of field. The preview
button fitted to many cameras allows a visual indication of its extent

Next, there's the mirror lock-up. Most of the noise and risk
of camera shake when you press the shutter release on your
SLR result from the mirror flying up before the shutter opens.
So when you're using the camera on a tripod you can lock the
mirror up out of the way to make the camera steadier and
quieter. The idea is to compose and focus your picture with
the camera set normally, then lock up the mirror before
making the exposure. In this mode the shutter becomes the
only moving part and vibration is virtually eliminated along
with the noise.

Then there's the shutter lock (also built into some other
types of camera). It prevents the shutter release being
pressed accidentally and wasting film. Sometimes it also
switches off the batteries which power the exposure meter
and shutter (on SLRs with electronically controlled shutters).
But there's another use. If you're using the camera on a
tripod and the exposure necessary is perhaps ten or more
seconds, you can use the lock to hold the shutter open for
the length of the exposure. For this long exposure the shutter
would, of course, be set to B.

And finally, there is the battery check, another control
often found on other types of camera. With the increasing
use of electronics in cameras, the condition of the batteries
which power the circuits is obviously most important. Most
cameras, therefore, have a battery check button. When this is

117

pressed a small lamp lights or the meter points to a special mark if the battery is in good condition.

It is a good idea to check the batteries each time you put a new film in the camera and to change them once a year even if they do not appear to be exhausted. Always carry a spare set of batteries with you, just in case. After all, with many cameras having electronically controlled shutters, if the battery fails everything grinds to a halt and you cannot take pictures.

Most 35 mm SLRs are fitted with a standard lens having a maximum aperture around f/1.8, though in many cases alternative standard lenses with larger apertures are also available, though usually at a far higher cost. Consider whether you really need the wider aperture before you spend that extra money which could go a long way towards a second lens.

Shutter speeds range from 1 second to $\frac{1}{1000}$ or $\frac{1}{500}$ second on manual cameras and often cover ten seconds to $\frac{1}{1000}$ or faster on automatic SLRs. The standard viewfinder system is the eye-level pentaprism, but one or two cameras offer alternative viewfinders such as waist-level. Most of the more

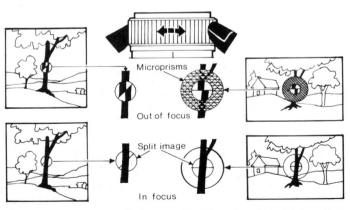

SLR 35 mm cameras usually incorporate a focusing aid in the focusing screen. Most commonly this is a combination of microprism and spot image

expensive SLRs offer interchangeable focusing screens, different types being suitable for specific jobs. But the standard screen fitted to most SLRs has a split image rangefinder centre with a microprism ring around it, all in the middle of the ground glass screen.

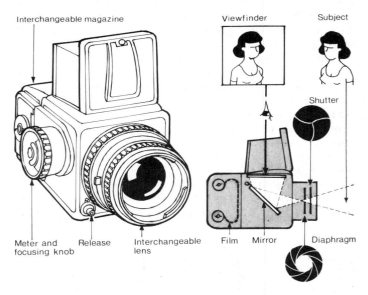

Interchangeable magazine

Viewfinder

Subject

Shutter

Meter and focusing knob

Release

Interchangeable lens

Film

Mirror

Diaphragm

6 × 6 cm SLRs are widely used by professional photographers. The basic camera can form the basis of a comprehensive system to rival most 35 mm systems. Waist-level viewing, with the image reversed, is common. A diaphragm shutter is normally available in some or all of the lenses to make electronic flash easy to use

Large format single lens reflexes have broadly the same advantages as 35 mm models, but are invariably fitted with waist level viewfinders rather than the eye-level pentaprism, though these are available as alternatives in most cases. The only exception as far as I know is the Pentax 6 × 7 which has a pentaprism as standard and looks just like a scaled-up 35 mm SLR whereas other large format SLRs are much boxier.

Twin lens reflexes

Until about fifteen to twenty years ago, it was the ambition of practically every serious photographer to own either a Leica – which we've already looked at – or a Rollei. Rollei is a name that was then, as now, synonymous with the twin lens reflex, or TLR. It became less popular as the SLR gained ground, largely because the SLR is a great deal more versatile, with interchangeable lenses, close-up bellows, and so on. But there are, I'm sure, a large number of photographers who buy an SLR with its standard lens and never use it with anything else. So all the sophistication built into the camera is wasted on them, along with a sizeable financial investment.

The twin lens reflex first saw the light of day in 1928 when the German company of Franke & Heidecke produced the first 6 × 6 cm format TLR called the Rolleiflex – a development

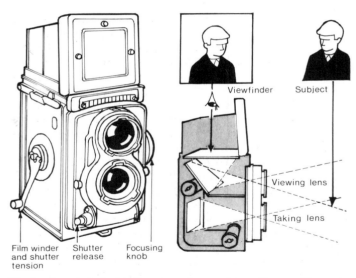

Viewfinder Subject

Viewing lens

Taking lens

Film winder Shutter Focusing
and shutter release knob
tension

The 6 × 6 cm twin-lens reflex, once the sturdy workhorse of journalists, still offers extremely high image quality from its normally fixed lenses. The waist-level screen view and lack of accessories make this a good camera for carefully composed shots

from a prototype stereoscopic camera built twenty years earlier by one of the partners in the company, Dr. Heidecke. In 1933 the company produced a less expensive version of the camera called the Rolleicord.

Rollei cameras today, although much neater in appearance and with added refinements, are still in essence the same as the original Rolleiflex of 1928. They've been copied many times by camera manufacturers throughout the world, but in my opinion have never been bettered. One reason for this is the extremely high quality of engineering which goes into the cameras and makes them so precise in use and so reliable. My own Rolleicord V, which I bought secondhand in 1959, has had many hundreds, if not thousands, of films through it and has never once let me down. And the only time it has ever had to go to the repairer's was when I carelessly allowed sand to get into it and had to have it cleaned. That's what I call reliability.

When it comes to viewfinding and focusing, the twin lens reflex has a big advantage over any other type of camera. You focus visually, rather than by rangefinder and, most important, the subject remains in view all the time, including the instant when you press the shutter release. There's no momentary blacking out of the focusing screen as there is with the SLR. And because there's no need for the mirror to swing up out of the light path, the whole of the camera can be made more simple – probably another reason for the excellent reliability.

All this is made possible by the concept of the twin lens reflex. It is, in effect, two cameras rigidly coupled together one above the other. The top camera acts as a focusing and viewfinding instrument while the lower one actually takes the pictures. Of course, because the viewfinding and taking lenses are separated by about two inches (5 cm), you run into the problem of parallax error. But some TLRs overcome this problem in a very clever way. They have a sliding mask built into the viewfinding system which is mechanically coupled to the focusing control. When the focusing knob on the side of the camera is turned, the mask slides and automatically compensates for parallax error.

Probably the biggest disadvantage of the TLR (with the sole exception of the Mamiyaflex) is that you can't change lenses, so you're stuck with a single focal length. But this can have its advantages. It means you have less equipment to carry about with you, less equipment to lose or get damaged, and less chance of losing a picture because you're busy changing lenses when you should be pressing the shutter release. The restrictions of a single focal length lens make you more selective, too.

Although on the face of it the TLR may appear to be rather lacking in versatility, there are plenty of accessories available for it, including close-up lenses, filters, sheet film adapters, 35 mm adapters and lots more. So if the kind of photography you do needs only a standard lens – landscapes, portraits, and so on – a TLR is certainly worth considering.

One other thing about the TLR; I find it a very relaxing camera to use, ideally suited to the leisurely setting up, composing and shooting of landscapes. I almost always use my Rollei on a tripod, often moving it several times before I'm satisfied with the composition. It is certainly not a camera to use for fast action, split second shooting, but more for the contemplative shots.

Sheet film cameras

To be honest, a sheet film camera will only be your choice if you're a really dedicated photographer demanding the ultimate in image quality for your pictures. The sheet film camera is not an easy instrument to use; it demands a fair degree of skill and devotion to do the job in hand. But the results it is capable of producing are far and away the best you'll get from any camera as far as sheer quality is concerned.

However, as I hope I made clear at the beginning of the book, the sheet film camera, while being one of the most versatile types, is only really suitable for applications where the subject is stationary. This is because the camera must be mounted on a tripod and, in most cases, once the subject is

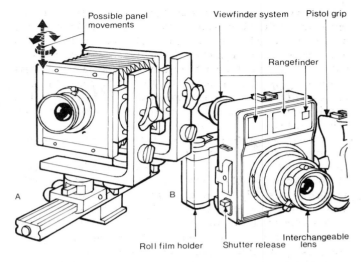

Possible panel movements

Viewfinder system Pistol grip

Rangefinder

A B

Roll film holder Shutter release Interchangeable lens

Sheet film cameras offer the largest negative or transparency sizes. A. Monorail models have to be used on a stand, and are confined mainly to the studio and landscape work. They offer an enormous range of lens and film movement, which allows the photographer to manipulate the shape of the image and the plane of sharp focus. B. Press cameras are more portable examples with less versatile movements. They are good for landscapes, exterior portraits and similar work

focused and composed, and the sheet film holder is inserted into the camera back, you lose your viewfinder image.

As far as concept and construction are concerned, the sheet film camera is the simplest of all advanced cameras with the lens and shutter on one board, the focusing screen on another, and the two joined by flexible bellows. There are no gadgets, no automatic exposure systems, no built-in exposure meters; it is really photography at the basic level and the results stand or fall by your own skill in using the camera.

Focusing a sheet film camera is achieved by moving the front panel holding the lens, or the rear panel holding the focusing screen, along the base of the camera. This may take

the form of a board with rack and pinion drive or, becoming increasingly popular, a single rail along which the panels can be moved for coarse focusing, a short rack and pinion being built in to give a fine focus control. In most cases no focusing scale is provided, so you have to focus entirely by examining the image on the ground glass screen at the back of the camera, draping a black cloth over the camera and your head to exclude extraneous light. It all sounds terribly crude, and in many ways it is. But there is no better way to learn about the technicalities of photography than by using a sheet film camera. It teaches you care, accuracy, and – because the necessary film for, say, a dozen photographs is bulky and heavy – it teaches you to make sure everything is as you want it before you press the shutter release; it rids you of the urge to shoot like a machine-gun as so many 35 mm users do.

But the main advantage a sheet film camera offers is image control. The camera incorporates various movements on the front and rear panels which enable you to control the position, shape and sharpness of the image on the focusing screen. These controls enable you to raise and lower the front and rear of the camera, to slide them from side to side, to tilt them about a horizontal axis, and to swing them about a vertical axis. Although the precise way in which these camera movements are used is outside the scope of this book, a couple of simple examples may show the principle.

Consider a tall building. In order to get the full height into your picture you would normally have to tilt the camera up, producing the well known effect of converging verticals, where the building appears to be falling over backwards. This is because the film in the camera is no longer parallel with the building. With the sheet film camera you leave the back of the camera upright and raise the lens panel until the entire building is in the picture. In this way the verticals remain straight and upright.

For the ultimate in sharpness and quality, the sheet film camera is the best choice. The combination of large negative size and camera movements gives you total control of the picture. Temple Balsall church, Warwickshire taken on a 5 × 4 in Sinar with 90 mm Super Angulon lens and orange filter (Derek Watkins)

If you're taking a picture of a collection of items on a table and you want them to appear sharp throughout, you may not be able to obtain sufficient depth of field, even with the lens fully stopped down. But if you're using a sheet film camera there is another control to help you. By tilting the back of the camera towards you, you increase the distance between the top of the focusing screen and the lens. This corresponds with the front of the subject which needs a greater lens extension to give a sharp image. Tilting the camera back gives it this extra extension, and by careful adjustment of the focusing and tilt controls it is possible to render the entire subject sharp, even at maximum aperture.

As I said earlier, the sheet film camera is not for the casual user; you need to be a really committed photographer before you even consider one. And unless the kind of photography you're interested in is one for which the sheet film camera is suited, then you may well be wasting your money; a lot of money, because sheet film cameras are very, very expensive.

Instant picture cameras

This type of camera, produced by Polaroid and Kodak, has become very popular in recent years, especially among holidaymakers. As the name implies, it enables you to take your picture and see the result instantly. Well, almost instantly; from a few seconds to about five minutes.

With the basic Polaroid cameras, you take the picture, pull a paper tab to remove a paper sandwich from the camera, wait fifteen seconds, then peel the print from one side of the sandwich; the other side contains the paper negative and used processing chemicals and is scrapped. A similar colour version is also available but in this case the waiting time is about a minute. A special black and white version producing a reusable negative as well as the print is also available.

However, the latest Polaroids, as well as the Kodak cameras, use a self delivery system. When you have pressed the shutter release to take the picture, a motor inside the camera

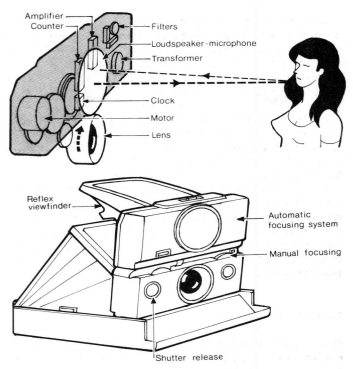

Amplifier
Counter
Filters
Loudspeaker-microphone
Transformer
Clock
Motor
Lens

Reflex viewfinder
Automatic focusing system
Manual focusing
Shutter release

Instant-picture cameras are always large, because they must accommodate a full-size picture. The Polaroid SX70 SLRs fold flat for easy carriage. Some models are fitted with a Sonar focusing system

pushes the print out of a slot and it then develops to its final colours in around five minutes.

Instant picture cameras vary in complexity from very simple, inexpensive snapshot machines with basic controls, to much more advanced models with rangefinders, full exposure control and focusing. They are, of necessity, rather bulky since they have to contain a pack of film and the mechanism to break the pods of chemical to start the processing cycle, but most models fold for carrying. Polaroid

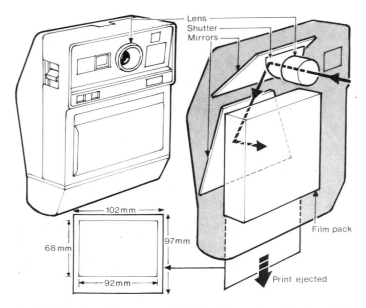

Lens
Shutter
Mirrors
Film pack
102mm
68mm
97mm
92mm
Print ejected

Kodak instant print cameras hold the film pack vertically which makes them a curious but easily held shape

attachments are also available for use with many larger format SLRs and sheet film cameras.

The big problem with instant picture cameras is the high cost of materials, which can easily put the cost per print to several times that of using a conventional system. Also, because you see the results so quickly, the temptation is to take rather more shots than you would otherwise.

7

Controlling the image

Apart from the camera movements on the sheet film camera, which you can use to control the position, shape and sharpness of the image making up your picture and which were described briefly in the previous chapter, the three basic adjustments on all types of adjustable cameras can be used to control the effect in your finished print or slide. These three controls are, of course, focus, aperture, and shutter speed.

The first two control what is and what is not sharp in the picture by enabling you to choose the point of focus and depth of field. And the third controls the degree of movement apparent in your picture. Let us take a closer look at the way in which these three basic adjustments affect the picture.

Depth of field

I mentioned earlier how the lens aperture you use controls the amount of the subject which is reproduced sharply in the negative or slide. A large aperture gives a narrow zone of sharpness while a small aperture gives a wide zone of sharpness. The way it works is like this.

When you focus the lens on a particular distance, only objects at this particular distance will be perfectly sharp. Objects in front of and behind it will be progressively less sharp. The two distances where this unsharpness becomes unacceptable are the limits of the depth of field.

Now whether or not a point is acceptably sharp is dependent on a strange illusion called the 'circle of confusion', which is simply the size of a circle which the human eye cannot distinguish from a point when both are viewed from normal reading distance. For most people, the size of this circle is roughly a quarter of a millimetre. Because photographs are enlarged from a smaller negative or projected from a small slide, the circle of confusion on the negative must obviously be far smaller than that which the eye can distinguish in order to allow for the degree of enlargement. In most cases the circle of confusion is related to the focal length of the standard lens and is normally specified as $\frac{1}{1000}$ or $\frac{1}{2000}$ of the focal length of the lens. In other words, for a 35 mm camera which uses a 50 mm lens, the circle of confusion is 0.05 mm to 0.025 mm.

While circle of confusion defines the limits of the depth of field, the circle of confusion itself is controlled by the aperture of the lens – the larger the diameter of the aperture, the smaller the depth of field, as already pointed out. But because the diameter of the lens aperture is a function of the focal length of the lens – it is, in fact the focal length divided by the f/number for any given stop – the depth of field at any aperture will vary according to the focal length of the lens. For example, the diameter of an aperture of f/8 is much larger in a 300 mm lens than it is in a 28 mm lens. At a focused distance of 23 feet (7 metres), the 300 mm lens will have a depth of field extending from 22.6 feet (6.9 metres) to 23.23 feet (7.1 metres) approximately, while at the same settings the depth of field on the 28 mm lens will extend from about 6 feet (2 metres) to infinity. This explains why the depth of field is greater on a 35 mm camera when fitted with its standard lens than it is on a larger format camera fitted with the standard lens.

Lenses on advanced cameras have a depth of field scale engraved on them. This takes the form of a series of f/numbers on either side of the focusing index and they enable you to check how much of your subject will be in focus. The simplest way to use it is to focus on your subject then read off the nearest and farthest points which will be

Indoors in available light, even a standard lens has a little depth of field, offering excellent opportunities for isolating the subject from the surroundings (Valerie Bissland)

acceptably sharp against the aperture you're using on the depth of field scale. But you can use the depth of field scale in a much more creative way, to obtain the maximum depth of field in your picture.

Say, for example, you're taking a landscape photograph with foreground interest and you want to have as much depth of field as possible at the aperture you're using, which is f/11 on a 50mm lens. Instead of setting the focus control to infinity, set the infinity mark to the f/11 position on the depth of field scale. This will mean that the lens is set to about 20 feet (6 metres) and if you look at the other f/11 mark on the scale you'll see that the nearest point to be sharp in the picture will be about 12 feet (3.6 metres). If you had used the lens set at infinity the nearest point in focus would have been 20 feet (6 metres).

So by using the focusing control on your camera in conjunction with the aperture control you can govern quite precisely how your picture will look. If you focus on a fairly close distance and use a wide lens aperture there will be very little in your picture that will be really sharp and you can use this to some effect in portraits by focusing on the eyes and allowing the hair and the back of the head to become progressively less sharp. But if you want to get maximum depth of field as in a landscape, for example, you would focus on a much greater distance and use a smaller lens aperture.

Depth of field on simple cameras

On simple Instamatic cameras where the only adjustment is to set a lever to an appropriate weather symbol, you may run into problems if this lever changes the aperture rather than the shutter speed. The reason for this is quite plain. If the lens in the camera is set to a distance which will produce sharp results from say 5 feet (1.5 metres) to infinity when set to the sunny position, the depth of field is going to be considerably less when you move the lever to the cloudy position. In this position you may find that the depth of field

doesn't start until about 8 feet (2.5 metres) and may well end at around 40 feet (12 metres) with the result that the far distance in landscape shots will be unsharp as will close shots of people.

Controlling movement

As already explained, the shutter speed governs the length of time the light which forms the image falls on the film, so in combination with the aperture setting it controls the exposure. But it also allows you to decide whether the subject of your picture is recorded as a sharp image or as a blurred one. In this way you can create a sense of movement in your pictures or freeze life for a split second.

Often the best way to show movement is to select a long enough shutter speed (here ⅟₁₅ with a 135mm lens) to blur the subject. Panning with the main movement allows some sharpness (Robert Ashby)

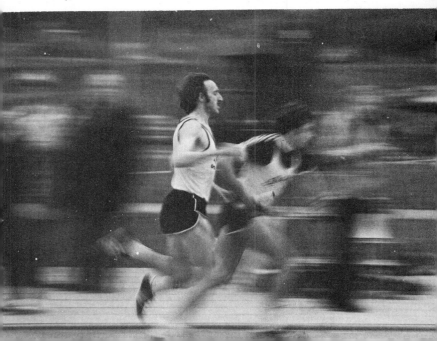

Whenever you take a photograph of a moving object the image produced on the film will show a certain amount of movement. However, if you choose a suitable shutter speed this movement will be so minute as to be invisible. The same applies to holding the camera; no matter how steady you think you are there will inevitably be a small amount of movement when you press the shutter release and at slow shutter speeds this movement will be sufficient to produce a blurred image on your negative or slide. Surprisingly, the slowest shutter speed at which you can consistently hold the camera still enough not to create movement in your picture is considerably faster than you may think – in most cases, as fast as 1/125 second. If you don't believe me, take a look at some of the pictures produced by Instamatic cameras. Many of them show a high degree of blur and yet the shutter speed most

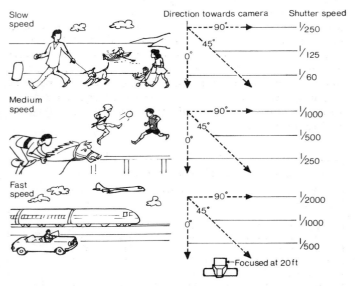

The faster a subject moves the faster the shutter speed needed to picture it sharply. The blurring at slower shutter speeds is much more marked when the movement is across the picture than when it is toward or away from the camera

commonly used in these cameras is ¹⁄₆₀ second, and some older cameras have a speed of only ¹⁄₂₅ or ¹⁄₃₀ second. So be warned. When you take photographs with any camera make sure you really are holding it still and squeeze the shutter release gently rather than jabbing at it, for this is a sure way to produce movement in your pictures.

But to get back to the photography of moving objects. Obviously, the faster an object is moving in front of your camera the faster the shutter speed you need to use to freeze it. And the closer to you the moving object is, again the faster the shutter speed you need to use. The direction of movement also has a major effect on the shutter speed you need to freeze a moving object. If the subject is moving directly towards you, you can get away with a slower speed than if it is moving across in front of you. In fact in a case like this you can move down two shutter speeds. For example, if you're taking photographs of a racing car about 50 feet (15 metres) away from you, you'll need a shutter speed of ¹⁄₁₀₀₀ second to stop the movement if the car is moving at right angles to you, but only ¹⁄₂₅₀ second if it is moving towards you. If the subject is moving diagonally in front of you the shutter speed you need will be between these two, in other words ¹⁄₅₀₀ second. The table gives suitable shutter speeds for photographing a variety of different types of moving subject travelling in different directions.

Shutter speeds for photographing movement

Subject	Distance in feet	Direction of movement		
		0°	45°	90°
People walking,	10	¹⁄₁₂₅	¹⁄₂₅₀	¹⁄₅₀₀
children, boats,	20	¹⁄₆₀	¹⁄₁₂₅	¹⁄₂₅₀
waves, etc.	50	¹⁄₃₀	¹⁄₆₀	¹⁄₁₂₅
Ball games, horse	10	¹⁄₅₀₀	¹⁄₁₀₀₀	—
racing, traffic	20	¹⁄₂₅₀	¹⁄₅₀₀	¹⁄₁₀₀₀
in towns, etc.	50	¹⁄₁₂₅	¹⁄₂₅₀	¹⁄₅₀₀
Racing cars, trains,	20	¹⁄₅₀₀	¹⁄₁₀₀₀	—
aeroplanes, etc.	50	¹⁄₂₅₀	¹⁄₅₀₀	¹⁄₁₀₀₀
	100	¹⁄₁₂₅	¹⁄₂₅₀	¹⁄₅₀₀

Fast moving objects

Certain fast moving objects such as racing cars, aircraft and so on move at such a high speed that even the fastest shutter speed on your camera may be too slow to stop the movement altogether when the object is moving across in front of you. In cases like this a technique called 'panning' is most useful.

Panning simply means to follow the subject as it moves in front of you, pressing the shutter release when it reaches a suitable position. It takes a little bit of practice to get it right but it is well worth the effort when you want to take this kind of shot. This is how you do it.

Assume you're photographing a racing car or motor bike. Pick up the vehicle in the viewfinder when it is still a long way off and still travelling more or less towards you. Keep it in the centre of the viewfinder and follow it round, pivoting your body at the hips and keeping your feet firmly planted on the ground. When the car or bike reaches a position in front of

Panning with a smoothly moving subject produces a sharp picture irrespective of speed. 1/125 with a 100mm lens blurs the background enough to emphasise the movement (Robert Ashby)

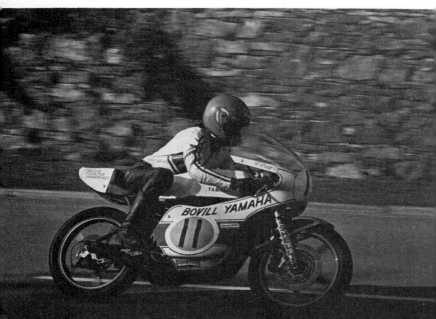

you press the shutter release, but continue to move the camera after the shutter has fired – rather like a golfer follows through a shot after actually hitting the ball. If you don't do this the camera will jerk to a halt as you press the shutter and the picture will show a blurred object.

The picture resulting from a panned shot taken in this way should show a sharp moving object against a blurred background caused by the movement of the camera. You can control the amount of blur in the background by choosing a suitable shutter speed. Remember that when you're panning, to all intents and purposes, the object you're photographing is stationary relative to the camera because you're following its progress with the camera. So you can choose quite a slow shutter speed – say $\frac{1}{125}$ second or even slower – and produce varying degrees of blur in the background. The slower the shutter speed, the more the blur. Pictures taken in this way convey a strong sense of movement far better than shooting with a very fast shutter speed where both the object and the background are frozen; they simply look like a stationary car posed against a stationary background.

Choosing the best shutter speed

Your choice of the best combination of aperture and shutter speed to use for a particular picture will depend very largely on the subject you're shooting. If it is a fast moving object you will tend to use a fast shutter speed and a fairly wide aperture, but if it is a shot where you need great depth of field you will use a small aperture and a correspondingly slower shutter speed.

But for pictures where there are no fast moving objects and great depth of field is not particularly important, perhaps the best solution is to use whatever shutter speed will allow you to shoot at an aperture two stops down from the maximum aperture of the lens. In other words, if your lens has a maximum aperture of $f/1.8$ you would choose the shutter speed which would allow you to use an aperture of $f/4$. Alternatively, shoot at the fastest convenient shutter speed,

137

trying to keep at $\frac{1}{125}$ second or faster whenever possible. Your choice of film will influence this quite considerably and I would suggest using a film with a speed of around 125 ASA to 200 ASA for as many of your pictures as you can. This avoids the necessity of using slow shutter speeds or wide apertures as you would have to with a slow film and it also avoids the more pronounced grain that you will get if you use a faster film.

Exposure as a colour slide control

If you shoot black and white film or colour negative films, you can control the lightness or darkness of your picture when you print the negative (or have them printed). But with a colour slide film this isn't possible. Once you have pressed the shutter release to take the picture there is very little else you can do to control the finished picture. But one thing you can do is to adjust the exposure to give you the kind of results you want.

Giving less exposure than your exposure meter indicates will produce darker slides, but with much more saturated colours, while giving more exposure than the meter indicates will give you lighter slides with paler colours.

So if you're shooting, say, a portrait of a pretty girl and you want the results to be soft and ethereal with luminous pastel colours, give half a stop or a whole stop more exposure than your meter indicates. And if you are shooting a pattern of brightly coloured beach umbrellas, for example, and you want to emphasise the strong rich colours, give half a stop less than the meter indicates.

A very quick and easy way to learn the effects of this exposure control is to use a technique called bracketing in your picture taking. This is a technique employed extensively by professional photographers and consists of taking a shot at the indicated exposure and one shot each at half a stop less and more exposure. And sometimes another shot each at a whole stop more and less. Professionals do this as a sort of insurance policy against the cost of reshooting a whole job

because the slides were not perfectly exposed. For the amateur just learning colour photography it is a useful technique to teach you the effects of under and overexposure, and while it does mean that you use more film than normal, you will quickly get to the stage where you can decide whether you want to over or underexpose slightly and just make the one exposure.

8

Extending the possibilities

The extent and scope of accessories and gadgets for cameras which are currently on the market is quite incredible, and if you bought a complete range of them you would be spending many times the cost of your basic camera. Some of these accessories are extremely useful, if not essential, and others are, in my opinion, quite useless. So what should you buy and what should you leave alone?

Lenshood

I am often asked which is the most useful accessory to buy for a camera and I have no hesitation in replying that a lenshood should be right at the top of the list. This reply is usually greeted with a look of absolute amazement because the questioner was quite convinced in his own mind before asking that I would tell him to buy an elaborate electronic flash unit or a motor drive for his camera. I will come to those in a moment. But for now, let us see why a lenshood is so important.

Many amateur photographers consider that it is necessary to use a lenshood only when taking photographs against the light to avoid the rays of the sun striking the lens and causing flare. This is true, but only up to a point. Flare can be caused even when shooting with the sun behind you, by light being reflected from shiny parts of the subject back into the lens.

The idea of a lenshood is to prevent this flare. The lenshood is simply a metal or plastics tube which attaches to the front of the lens and acts as a shade. The important thing is to choose a lenshood which is properly designed for the lens you are using. The best solution to this is to buy one made by the lens manufacturer, because that will be designed specifically for the lens you have. If the lenshood is too short it will not do its job properly; if it is too long it will cut off the corners of your picture. The same thing will happen if you use a lenshood for a standard lens on a wide-angle lens.

A. A lenshood is intended to keep stray light from reaching the front of a lens. B. If the hood covers too narrow an angle, the picture will show vignetting at the corners

Many lenses for the better quality SLR cameras are now supplied complete with a lenshood which is obviously designed especially for that particular lens. However, if you are buying a lenshood from a different manufacturer, examine it carefully before you part with any money. Look particularly for the finish on the inside of the lenshood. This should be a good matt black – I've seen some in which the finish is quite shiny and this would render the lenshood completely useless because rays of light would simply bounce off it into the lens.

If you have an SLR, fix the lenshood to the lens and look through the viewfinder. Stop the lens down to its minimum aperture and operate the preview button to close the lens down. Check carefully in the corners of the viewfinder image

141

to make sure there is no sign of cut-off caused by the lenshood. This will give you a rough idea of whether the lenshood is suitable for the camera, but since most SLR viewfinders show slightly less of the subject than is actually recorded on the film, it is best to check the performance of the hood by taking a couple of shots and having them processed before you buy the lenshood.

A good lenshood will make your photography much more enjoyable because it will free you from doubt as to whether you will have flare on your pictures or not, and it comes into the category of accessories which I consider to be indispensable. A few years ago when cameras were much larger, the front element of the lens in most cameras was fairly well recessed and a lenshood was not absolutely essential unless you were using a filter as well. But with the trend towards smaller cameras, the lens is hardly recessed in its mount at all, so it is much more vulnerable to stray light which will cause flare. The problem is much more acute with wide angle lenses than with standard and telephoto lenses because of their increased angle of view.

Filters

Filters seem to be enjoying something of a comeback at the moment and there is an enormous range of them on the market. This renewed interest in filters has been a result largely of the introduction of a French system of interchangeable holders, mounts and filter elements which makes the use of filters quite inexpensive. But conventional filters, too, which screw into the front of the lens mount, are available in a wider variety than ever before.

A great many of the filters available fall into the category of gimmick devices and are not worth buying unless you want to make extensive use of special effects. Among these are starburst filters, shaped masks, filters which are half one colour and half another, rainbow effect filters and so on. Personally, I haven't got a great deal of time for any of them. More conventional filters are a different thing altogether. They can help you improve your pictures quite considerably.

142

Filters for black and white

If most of the pictures you take are outdoor shots of landscapes, architecture etc., the most useful filter you can buy is the medium yellow. This is the filter that darkens blue sky slightly to increase the contrast between it and white clouds – it brings out the clouds better! It also lightens yellow objects slightly. If you use a yellow filter, you'll need to increase the exposure indicated by your meter by one stop, unless you are using a TTL meter, in which case the effect of the filter will be taken into account automatically.

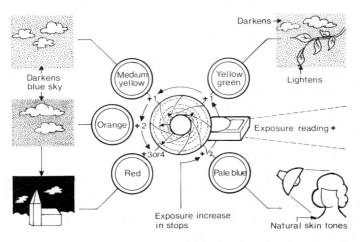

Black-and-white tone reproduction can be altered with coloured filters. As they absorb some light, they demand extra exposure. Open up the lens aperture from the normal exposure to compensate

For photographers specialising in landscape photography I find the yellow-green filter more suitable than a plain yellow. In addition to darkening the blue sky to make the clouds reproduce better, it also lightens green leaves and grass to produce more detail in these areas and to increase the overall contrast of the scene. Like the yellow filter, it needs an exposure increase of one stop. These two filters are the only

ones that I would advise for normal black and white photography, but there are one or two others which may be useful if you want to create a particular effect.

First is the orange filter. This darkens blue skies rather like the yellow but to a much greater degree and will make the effect rather artificial. However, it is quite useful for architectural photographs because it will lighten brickwork slightly to make the building stand out better against the sky. An orange filter needs an exposure increase of two stops.

A red filter is often used by architectural photographers to achieve maximum contrast or separation between red brick buildings and the sky. With a red filter the sky will be darkened to the point where it is almost black and this can be quite useful in creating a pattern effect with buildings. But it is a filter which you should use with great restraint because the effect really is quite unnatural. And don't be tempted to use it for landscape work because it not only darkens the blue sky, it also darkens greens, so the whole effect is one of deep depression. The red filter needs an exposure increase of three to four stops.

Taken at Stokesay Castle, Shropshire, using a yellow-green filter to darken the sky and lighten the grass and foliage. Olympus OM-1 with 70–150 mm Tamron zoom lens (Derek Watkins)

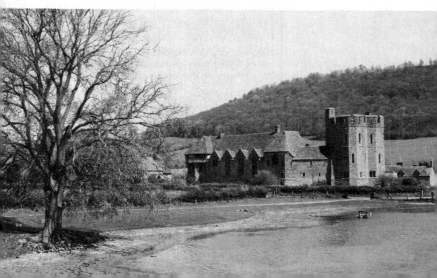

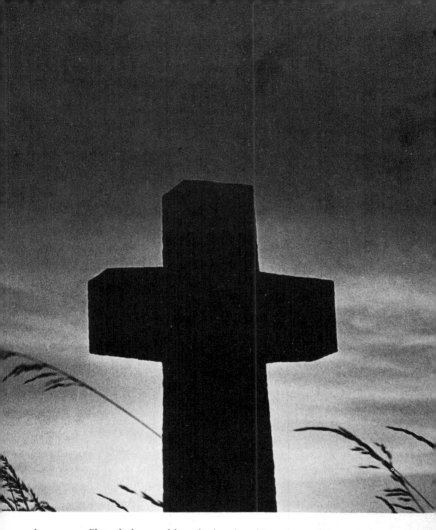

An orange filter darkens a blue sky by absorbing most of the blue light. Note, too, how the development effects emphasise the border of the solid black cross (Ron Tenchio)

If you like to take portraits indoors by artificial light a pale blue filter is quite useful. It will enable more natural reproduction of skin tones and if your sitter has blue eyes it will lighten them slightly to give a much more flattering appearance. This filter needs no exposure increase usually, or half a stop at the very most.

Filters for colour

Probably the most used filter of all by amateur photographers is the ultra-violet or skylight filter for colour work. Many photographers screw one on to the front of the lens and

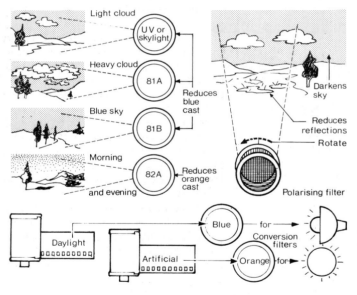

Coloured filters change the colour of colour pictures, so they are used only to correct for unusual lighting, or for effect. Pale salmon filters make transparencies more warm-looking; pale blue ones more cool

leave it there permanently, which is fine as long as you remember to keep it clean.

The skylight filter is, in fact, quite a useful one to use with colour film in normal daylight conditions when the subject is lit by a mixture of sunlight, blue sky and light reflected from white clouds; it prevents excessive blue in the colour slides. However, it is not a great deal of use if the subject is lit predominantly by the sky rather than the sun. In this case the light is considerably bluer than sunlight and a rather stronger filter helps.

Two of the stronger filters generally available are called 81A and 81B respectively. The 81A is most useful when the conditions are fairly cloudy and the 81B should be used when the subject is lit largely by blue sky or where there are fairly large areas of shadow in the picture. Without the 81B filter, the shadow areas would become very blue indeed since they are lit entirely by blue sky.

If you want to take pictures fairly late in the afternoon or in the evening or early morning, an 82A filter will be very useful. This is a pale blue filter which countracts the rather orangey light of the early morning and evening.

Perhaps the most useful filter of all for colour photography is the polarising filter. This does two quite different jobs. First it reduces reflections from non-metallic surfaces such as windows, shiny table tops, and so on, and secondly it can be used to darken blue skies. Both these jobs it does without changing the other colours in the subject, and it is, in fact, the only filter which you can use with colour film that will enable you to darken the sky.

The polarising filter works on exactly the same principle as Polaroid sunglasses – in fact it is made from the same material. When using a polarising filter you will have to increase the exposure indicated by your meter by one to two stops although if you are using a camera with TTL metering this will be taken into account automatically.

With a polarising filter in use on an SLR camera you can simply attach the filter to the lens, look though the viewfinder and rotate the filter in its mount until you get the effect you want. When using the filter with other types of camera

you have to look through the filter at your subject, rotate it in its mount, and make a note of the setting of the filter (polarising filters have an indicating pointer to enable you to do this). Then when you fix the filter to the camera you must ensure that the indicating pointer is in the same position as when you looked through the filter.

Diffusers

A filter that seems to be getting a lot of use at present in both black and white photography and colour is the diffuser. This is a colourless filter with a sort of misty appearance which spreads the light passing through it to give a soft focus effect. It is particularly useful for taking portraits of attractive young ladies, especially when you are using backlighting to give a halo effect around the hair. Bright light from the highlight areas of the subject spreads over into the shadow areas and makes them more luminous, and the diffusing effect smooths out the skin tones beautifully to make a very flattering portrait.

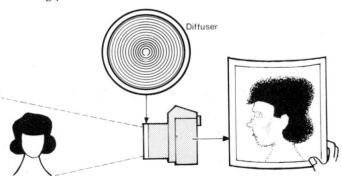

Diffusers can introduce a degree of softness to portraits and other pictures

Diffusers are normally available in two strengths and neither needs any increase in exposure. You can also use them together if you want a particularly strong diffusion effect.

Close-up attachments

A great many photographers become interested in close-up work, which is rather a specialised branch of photography. There are a lot of attachments available for close-up work, of which the simplest and, in many ways, the most useful, is the close-up lens. This is attached to the front of the camera just like a filter but is in effect a weak magnifying glass.

The close-up lens changes the focusing range of the camera to enable it to focus on subjects much closer than its normal closest limit. Most cameras have a focusing range from about 3 feet (1 metre) to infinity. With a number 1 close-up lens this focusing range is changed to about 1.5 feet (0.5 metre) to 3 feet (1 metre), and with a number 2 close-up lens the range is changed again from about 1 foot (0.3 metre) to 1.5 feet (0.5 metre).

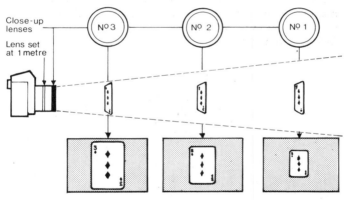

Close-up lenses offer closer than normal focus to give larger images

The big advantage of the close-up lens is that you can simply screw it on the front of the camera lens and shoot in the normal way, as long as you remember to focus accurately. With an SLR, of course, you simply look through the viewfinder in the usual way, but with other types of camera you need to measure the distance accurately with a tape

measure. Twin-lens reflexes usually have close-up lenses in pairs – one for the taking lens and one for the viewfinder lens, and in some cases a wedge attachment is also provided which fits in front of the viewfinder lens to correct for parallax error.

Close-up lenses are available in a range of strengths and require no increase in exposure when in use. You can use them together to give greater strengths, too. For example a number 1 and a number 2 together give the same effect as a number 3.

If you use a single lens reflex there are two alternative attachments you can use instead of close-up lenses. One is the extension tube and the other is extension bellows. Both do basically the same job.

Extension tubes and bellows are fixed between the lens and the camera body and this enables the camera to be focused at much closer distances. Extension tubes are usually available in a set of three or four which enable you to produce an image on the negative or slide up to the same size as the subject itself. The tubes are used in various combinations to give the magnificaton required. Extension bellows do exactly the same thing except that they are

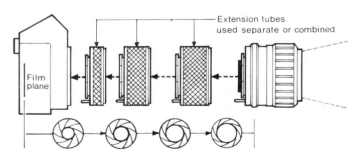

Increased lens distance = increased exposure

Extension tubes move the lens away from the camera, thus giving closer focus. At the same time, they reduce the image brightness, thus the greater the extension, the larger the aperture needed for any particular conditions

150

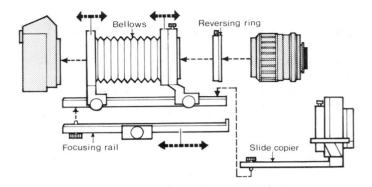

Bellows offer greater versatility and greater magnification. A reversing ring allows the lens to be turned round for magnification greater than 1. Most bellows can be fitted with a slide holder, and a focus rail to simplify positioning the whole outfit

continuously variable and are therefore probably quicker and easier to use. They are also considerably more expensive. The main problem with both extension tubes and extension bellows is that they need an increase in exposure over that indicated by the meter, and this increase varies with the length of the extension tube or bellows. For example, if shooting to provide an image on the negative or slide the same size as the subject, you will need to increase the exposure by two stops or multiply the exposure by four. Tables of exposure increases are supplied with the extension tubes or bellows, but again if you are using a single lens reflex camera with TTL metering the extra extension is taken into account when you make the meter reading.

One point to bear in mind when taking close-ups is that, because you are so close to your subject, even the smallest amount of camera movement will throw your subject out of focus or cause it to blur. For this reason it is advisable always to use a tripod and, in fact, this piece of equipment is another of those accessories which I consider indispensable for serious photography.

Tripods

There are a great many tripods available in camera shops, many of which are quite useless. These are the very light-weight models which telescope into a length of about 9 or 12 in (23 or 30 cm) when closed. They are very easy to carry about but when opened their legs are very whippy and allow the camera to move about almost as much as if you were

There are many accessories for holding a camera steady. A. A ball and socket head allows the camera to be aligned when the support is fixed. B. A pan and tilt head provides precise control, ideal for panning. With rectangular-format film, the head needs an extra horizontal/vertical hinged platform. C. The classic tripod is still the best portable camera support. D. A table tripod is smaller and lighter and can be very useful. E. A shoulder pad is excellent for long lenses when no other support is available. F. A swivel allows easy panoramic shots on a tripod or other firm support. G. A pistol grip helps some photographers. H. Small clamps are excellent in the country where trees, gates and so on can then support the camera. J. Although not steady like a tripod, a monopod is a great help, and very portable

holding it by hand. When you buy a tripod choose one which is strong and rigid when fully exended and preferably has a geared centre column to enable you to adjust the height precisely. This type of tripod will be larger and heavier than the small lightweight type, but at least it will hold your camera steady. Also make sure that the tripod you buy has a fully adjustable pan and tilt or ball and socket head fitted to it. This enables you to move the camera round to various positions without having to move the tripod itself.

Auto-winders

Auto-winders seem to be the current 'in-thing' of photography, and if you believe some of the advertisements for SLRs you would be forgiven for thinking that you couldn't possibly take a picture unless your camera is equipped with an

Separate winder

A

Winder incorporated in camera

B

Most single-lens reflex cameras can be fitted with an accessory power winder. Some have electric drive built in. Motors are ideal for fast action, and for remote or semi-remote control with the camera firmly mounted

auto-winder or a motor drive. There is even a pocket In-stamatic now being produced with an auto-winder device built in.

An auto-winder is simply a motorised attachment which fits on to the bottom of the camera – usually an SLR – and winds the film on automatically when you have taken the picture. In fact you just press a button on the winder; this releases the shutter and winds the film on ready for the next shot. A motor drive does the same thing but continues to take pictures one after the other until you take your finger off the button again. Believe me, you can get through a lot of film that way!

There are times when an auto-winder can be a help; if you are taking pictures in rapid succession, for instance. But consider carefully the number of times you are likely to take pictures in rapid succession and weigh this against the cost of the auto-winder before you part with your money. You will probably find that the cost of using an auto-winder is quite staggering.

As you've probably gathered, I don't have a great deal of time for auto-winders. It seems rather silly to me that everyone has been clamouring for compact, lightweight SLRs ever since Olympus introduced the OM-1 in 1973, and now they've got them they hang a great heavy auto-winder on the bottom which virtually doubles the size and weight of the camera.

Auto-winders and motor drives are fine for professionals – for whom they were originally designed anyway – who often have to work very quickly and take an awful lot of shots in a short space of time. But the amateur photographer would be much better advised to spend his money on accessories that will really help to improve his photography, such as an extra lens, a decent flash unit, or even a good tripod.

Flash

I have deliberately left this accessory until last because it is probably one of the most popular yet most misunderstood accessories in photography. The type of flashgun which is

154

most commonly used is one which fits on the camera and is designed for taking pictures indoors in average sized rooms. For this purpose they are perfect. They are not designed for taking pictures in large areas or outdoors over great distances and for this job they are no good at all. Yet when you watch a sporting event such as ice skating on television, you can see hundreds of people taking photographs from positions way back in the audience and using flash. In a case like this flash has absolutely no effect whatsoever because by the time the light has travelled from the flashgun on the camera to the subject in the skating rink it has been reduced so much in brightness that it does not supplement the available lighting in any way. So all these people taking pictures with flash in large sports arenas are doing no more than wasting film and flashbulbs.

Having got that out of the way, let us now take a look at the way in which flash can be used successfully.

Types of flash

Flashguns fall broadly into two categories – bulb type and electronic type. Most cheap Instamatic cameras are designed to use flashbulbs in the form of Magicubes. These plug directly into the camera or into the camera via a stalk which raises the flashbulb slightly higher above the lens. As you press the shutter release on the camera the flashbulb is triggered mechanically and when you wind the film on the Magicube rotates until the next flashbulb is in the correct position. This is a very simple, if expensive, way to take flash photographs and is perfectly adequate for the kind of pictures users of Instamatics are likely to want to take.

However, with the advent of micro-electronics, tiny but powerful electronic flash units are now available and can be fitted to many of the more advanced Instamatic cameras as well as to all other types of camera. Not so long ago, an electronic flash unit with the same amount of power as a modern unit which you can hold in the palm of your hand would have needed quite a large flashgun which attached to the camera and an even bigger power pack which was

normally carried over the shoulder like a camera gadget bag and weighing several pounds. Today, most small electronic flashguns are designed to attach to the camera by means of a hot shoe, which is simply a device to hold the flashgun on top of the camera but with built-in electrical contacts to synchronise the flashgun with the shutter. When you press the shutter release, at the same time as the shutter opens, a pair of contacts close to complete the electronic circuit which

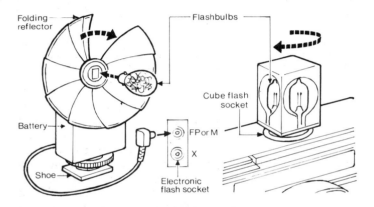

Bulb flash is now almost restricted to cubes or bars, but even a small bulb produces more light than most portable electronic flashes. Large professional bulbs can solve some lighting problems

fires the flashgun, so that the flash fires at precisely the same time as the shutter is fully open. Older cameras don't have hot shoes but instead have a small socket into which a cable from the flashgun is plugged. Many of the more expensive cameras have both a hot shoe and a socket so that the flashgun can be used on or off the camera.

Where a flash socket is fitted it is often accompanied by a small lever marked M or FP and X; sometimes two separate sockets, one marked M or FP and the other marked X are fitted instead. The X setting is for use with electronic flash units and the M or FP setting is for bulb flashguns.

156

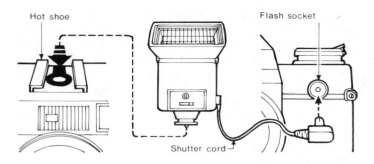

Hot shoe

Flash socket

Shutter cord

Electronic flash produces convenient lightweight portable lighting. Most cameras have a flash contact in their accessory shoe. For off-camera flash, connect to the camera's 3mm coaxial flash socket

Whether the lever or second socket says M or FP depends on the type of camera. If it has a diaphragm type shutter it will be labelled M and if it has a focal plane shutter it will be labelled FP and the type of bulbs that you use with the camera should also be labelled M or FP respectively. The main problem is that focal plane type bulbs are difficult to come by and even if you do find some they will tend to be rather expensive. But nowadays bulb flashguns are very rarely used so you will nearly always be using X synchronisation anyway.

One point to bear in mind about using an electronic flashgun with a camera having a focal plane shutter is that you must set the shutter speed on the camera to a suitable speed. This will generally be ⅟₆₀ or ⅟₁₂₅ second or slower depending on the type of camera, so consult the instruction leaflet before you take flash photographs. Some cameras have a special shutter speed for use with electronic flash. The reason that you must choose your shutter speed carefully with a focal plane shutter is because of the way the shutter exposes the film in strips when set to fast speeds, as explained in Chapter 2. Because the length of the flash which an electronic unit produces is usually ⅟₁₀₀₀ second or faster, if you use any shutter speed where the trailing blind has started

to cross the film before the leading blind has finished, only part of the negative or slide will be exposed. On most cameras the speed used is $1/60$ second or $1/125$ second. My own small electronic flash has a label on the back to remind me of this.

Exposure for flash

You cannot use an ordinary exposure meter to determine the aperture at which to set your camera when using flash because the duration of the flash is so short that it would not register on the meter scale. And although there are special flash meters available, which respond to the flash and hold the reading, these are specialist professional instruments and are expensive.

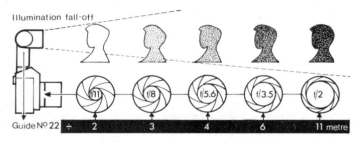

Illumination fall-off

Guide Nº 22 ÷ 2 3 4 6 11 metre

The further from the flash the less the light. With manual flash control, the aperture is set according to the guide numbers. With automatic control, the guide number determines the maximum distance possible

However, the light output of a flashgun is constant, unlike daylight which is changing all the time, so it is possible to work out the correct aperture as long as you know the distance from the flash to the subject.

Flashbulbs and electronic flashguns are given a guide number by the manufacturer. To find out the correct aperture at which to set the lens you simply divide the guide number by the distance from the flash to the subject in feet or metres. (The instruction booklet with the flash unit will tell

you whether the guide number is for feet or metres; most booklets quote both.) For example, if the guide number for your flashgun is 56 and the instruction booklet tells you that this is for distances in feet, you can quickly work out that if the flashgun is 10 feet from the subject the aperture that you need is f/5.6 (56 divided by 10).

Of course, this guide number applies only to films of a particular speed and this information is given in the instruction manual, too. For films of other speeds you simply multiply or divide the guide number by the difference in film speed. For example, if the guide number is 56 for 50 ASA films, it will be 112 for 100 ASA films or 28 for 25 ASA films. Most small flashguns have a calculator built into them which enables you to see at a glance the correct aperture to use for various flash to subject distances. You simply set the calculator to the speed of the film you are using and read off the correct aperture against the distance your camera is focused on.

Computer flash

Another result of more advanced electronics is the so-called computer flash, which is a system of providing automatic flash exposure. When the flash fires an electronic sensor built into the front of the flashgun detects the light reflected back from the subject; when the amount of light reaches the point of correct exposure an electronic switch inside the flashgun turns off the flash. So at close distances or when photographing very light subjects the duration of the flash is much shorter than when you are shooting at longer distances or photographing dark objects.

To use one of these computer flash units is very simple indeed. You merely set the lens aperture to the stop you wish to use then set the same aperture on the controls of the electronic flash unit, making sure also that the film speed setting on the flashgun is correct for the film you are using. Then attach the flash unit to the camera and shoot away.

Several of the computer flash units have a warning light built in which tells you if the light reflected back from the

subject is insufficient for correct exposure, even when the duration of the flash is at its maximum. Obviously, if the light comes on when you have taken a picture you have probably wasted the shot, so if you are in any doubt about whether the flash distance is too great, press the open flash button to fire the flash unit without exposing the film. Then if the warning lamp tells you there is insufficient light, you can move closer or open the lens to the next larger stop.

For most normal flash photography, the computer flash is ideal, as long as you know how to over-ride it if you come across an unusual subject. For example, if the subject is

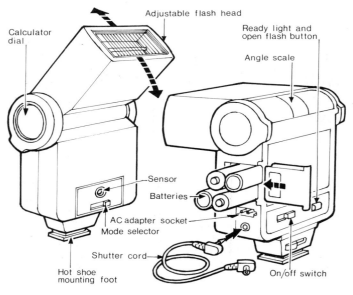

Adjustable flash head

Calculator dial

Ready light and open flash button

Angle scale

Sensor

Batteries

AC adapter socket
Mode selector

Shutter cord

Hot shoe mounting foot

On/off switch

Electronic flashes offer adjustable flash direction for bounced lighting, and automatic exposure control. Most are powered by 2 or 4 pen cells

predominantly light in tone the sensor in the electronic flash unit is going to cut off the flash before the subject is correctly exposed because it will reflect a lot of light. In a case like this

you simply set the aperture on your lens half a stop or a whole stop wider than the setting on the computer flashgun. If the subject is predominantly dark set the aperture on the lens half a stop or one stop smaller than set on the flashgun.

Using flash

Although practically every camera produced these days has a shoe on top of it in which to fit a flashgun, this is probably the least suitable positon of all in which to have the flash unit.

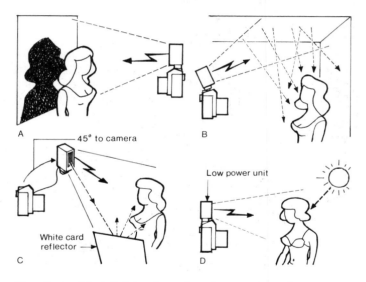

The effects of flash lighting depend on the way it is used. A. Directly on the camera, the lighting is flat and shows harsh shadows behind the subject. B. Bouncing the light from a white ceiling or wall produces much softer illumination, usually more flattering. C. Moving the flash away from the camera on a long lead provides good modelling; a white reflector prevents the contrast being too high. D. Flash can be used to fill in the shadows in strong sunlight. Aim to underexpose them about 1 stop to keep the picture looking natural

Light from a flash unit mounted on the camera provides very flat illumination which makes for rather featureless faces, and any shadows that are produced tend to be inky black and very sharp. Much better lighting is provided by moving the flash unit from the camera to a position about 45° to one side and slightly above the level of the lens. This gives much better modelling to the face, although the shadows are again rather dark. But these can be lightened by using a piece of white card or newspaper to reflect some light back into the shadows.

An even better way is to use bounce flash. This technique consists simply of directing the flash unit at a white wall or ceiling to spread the light before it reaches the subject. This produces a much softer light which does not give hard shadows but creates gentle moulding of the face.

The problem is, if you are using a computer flashgun the sensor will measure the light reflected from the wall or ceiling rather than that reflected from the subject. However, many of the latest computer flashguns have a means of tilting the head upwards or to one side while leaving the sensor facing the subject, and some have a separate sensor which is attached to the camera allowing the flash unit to be placed in any position or directed towards a wall or ceiling and still provide correct exposure.

Index

164